Come FORWARD Emerging Art in Texas

Suzanne Weaver
Lane Relyea

Come Forward: Emerging Art in Texas begins a celebration of the Dallas Museum of Art's centennial year by saluting the long and enriching relationship the museum has enjoyed with artists living in Texas. It was the noted Dallas painter Frank Reaugh who urged that an art gallery be incorporated into the plans for the city's new public library building that was to be erected through the beneficence of Andrew Carnegie. This gallery, which opened in 1901, proved to be such a popular success that community leaders were inspired to found a new entity with the specific mission of furthering the visual arts in the city. The Dallas Art Association, established in 1903, would eventually bear the name of the Dallas Museum of Art. Among its founding trustees were Reaugh and fellow artist Edward G. Eisenlohr, who would author the first catalogue of the young Association's collection in 1916. Through exhibitions, acquisitions, education programs, and annual artist awards, this ancestral organization established the DMA's tradition of encouraging, presenting, and preserving the achievements of talented artists from the region.

From 1938 until 1941 the Museum provided space for Olin H. Travis's Dallas Art Institute, established in 1926 as the first professional art school in Texas. In 1941, the Museum's trustees created their own Museum School, which offered studio training for 25 years. The School, first headed by Jerry Bywaters and later by Otis Dozier, had many artists of distinction from the community on its faculty rolls over the years.

In addition to mounting annual exhibitions of Texas artists for several decades from the late 1920s forward, the Museum has presented a number of major exhibitions of regional artists. *Texas Panorama* was organized in 1943 by Bywaters, the Museum's director from 1942 until 1964, who was a gifted painter, influential teacher and critic, and nationally known advocate for the important school of Southwestern regionalists centered in North Texas. The Museum presented *A Century of Art and Life in Texas* in 1961, and in 1985,

Lone Star Regionalism: The Dallas Nine and Their Circle, 1928–1945. A large and broadly based reinstallation of twentieth-century Texas art from the Museum's permanent collection, *The State I'm In: Texas Art at the DMA*, was shown in 1991. Since 1981, the work of more than thirty artists working in the region has been featured as part of both *Concentrations*, an on-going series of project-based exhibitions highlighting the work of emerging artists, and *Encounters* (1992 through 1995), a series that paired an international artist with an artist living in Texas. Additionally, the Museum has organized touring mid-career survey exhibitions of the work of such artists associated with Texas as James Surls and Linda Ridgway, and hosted major traveling exhibitions of the art of Robert Rauschenberg, Donald Judd, Nic Nicosia, and Luis Jimenez.

The Museum also has been an active collector of both historical Texas art and the work of contemporary artists living in or closely associated with Texas. It is fortunate to possess the most important body of work (substantial portions of it given by Bywaters, Dozier, and Eisenlohr) by the regionalist school of the 1920s, 1930s, and 1940s, and its dynamic contemporary collection stands among the few significant institutional holdings of this kind. Since the 1963 merger of the Dallas Museum of Fine Arts and the lively but short-lived Dallas Museum for Contemporary Arts, the place that the work of living artists has always occupied in the DMA's program has been emphasized even further.

The genesis of *Come Forward: Emerging Art in Texas* was our sense that a fresh, energetic, and forward-looking exhibition would be the best way to celebrate the extensive relationship the Museum has been privileged to have with artists in Texas. DMA's Associate Curator of Contemporary Art, Suzanne Weaver, enlisted as her co-curator Lane Relyea, currently Assistant Professor of Art Theory and Practice, Northwestern University, Chicago, and former Associate Director in charge of the Core Residency Program and Art History, Glassell School of Art, Museum of Fine Arts, Houston. Ms. Weaver brought her

Table of contents

curatorial experience working with young talent together with Mr. Relyea's background as a scholar, teacher, and critic, the better to assure an exhibition that would convey both conceptual and visual acumen. Their main objective was to find artists whose work is young but shows a conviction, clarity, and ambition that defy geographic borders, whose work history lies not behind but before them. Furthermore, to insure the critical import of the exhibition, the co-curators decided to focus it tightly, and to include in the catalogue essays by emerging writers associated with strong art-writing programs in Texas.

To begin their search for the most promising new art in Texas, Ms. Weaver and Mr. Relyea formed an advisory committee of faculty from influential art schools and museum curators from major artistic centers in Texas. In an all-day session, each member of the advisory committee presented to their colleagues information about artists, graduate students, and former students in Texas whose work they found to be especially innovative and imaginative. There were several informal discussions with other informed individuals who could not attend. Then, mostly during an intense two-week period, Ms. Weaver and Mr. Relyea visited some sixty artists' studios in El Paso, North Texas (Denton, Fort Worth, and Dallas), Austin, San Antonio, and Houston.

The result of their research is an exciting exhibition featuring eleven talented artists—Augusto Di Stefano (San Antonio), Adrian Esparza (El Paso), Joey Fauerso (San Antonio), Robyn O'Neil (Houston), Robert Pruitt (Austin), Juan Miguel Ramos (San Antonio), Irene Roderick (Austin), Chris Sauter (San Antonio), Brent Steen (Houston), Marshall Thompson (Carrollton), and Brad Tucker (Houston)—that confirms the rewards of experiencing work that is youthful, experimental, and risky. Considered as a whole, the eleven individual visions present an engaging picture of a generation of artists now emerging in Texas and of the future of art in the Lone Star State.

We express our particular thanks to Suzanne Weaver and Lane Relyea for their central contributions to the development and realization of this project. We appreciate the invaluable counsel of the members of the advisory committee: Diana Block (Director, Art Gallery at University of North Texas), Kate Bonansinga (Director, Art Galleries, University of Texas at El Paso), Frances Colpitt (Associate Professor of Art History and Criticism, University of Texas at San Antonio), Dana Friis-Hansen (Director, Austin Museum of Art), Aaron Parazette (Assistant Professor of Art, University of Houston), Willie Ray Parish (Professor of Art, University of Texas at El Paso), John Pomara (Assistant Professor of Art, University of Texas at Dallas), and Melvin Ziegler (Assistant Professor of Art and Art History, University of Texas at Austin). We are grateful to the authors who prepared critical texts for this publication: Ms. Weaver, Mr. Relyea, Jennifer Davy (master's candidate in art history and criticism, University of Texas at San Antonio), Alexander Dumbadze (doctoral candidate in art and

art history, University of Texas at Austin), and Hilary Wilder (Core Resident in Critical Studies, Glassell School of Art, Museum of Fine Arts, Houston). For their special efforts on behalf of this catalogue, we thank its editor, Alice Gordon, and its designer, Sibylle Hagmann, who complete an all-Texan publications team. Angstrom Gallery in Dallas, Inman Gallery in Houston, Carrington Gallery and Finesilver Gallery in San Antonio, and Lombard-Freid Fine Arts in New York must also be thanked for their assistance. We acknowledge with gratitude the efforts of Dallas Museum of Art staff members Bonnie Pitman, Wood Roberdeau, Tamara Wootton-Bonner, Gabriela Truly, Ellen Holdorf, Elayne Rush, Victoria Estrada-Berg, Brad Flowers, Giselle Castro-Brightenburg, Michael Mazurek, Diana Duke Duncan, Kevin Button, Evan Forfar, Tracy Bays, Anne Adcock, Yun-Jeong Min, Charles Wylie, Eric Zeidler, Gabriele Woolever, Chad Redmon, and the many others who helped with this ambitious undertaking.

From the very outset of this project, Nancy and Tim Hanley, exemplary patrons of the best of Texas art and architecture, unstinting advocates for the work of the artists of our region, and generous supporters of the cultural life of Dallas, have provided encouragement and sponsorship. Their lead gift has been handsomely supplemented by the DMA's Contemporary Art Fund, a resource afforded the Museum through the benefactions of an anonymous donor along with Naomi Aberly and Lawrence Lebowitz, Arlene and John Dayton, Mr. and Mrs. Vernon Faulconer, The Hoffman Family Foundation, Cindy and Howard Rachofsky, Evelyn P. and Edward W. Rose, Gay and Bill Solomon, Gayle and Paul Stoffel, as well as the Hanleys. Additional support for the presentation in Dallas has been provided by the National Endowment for the Arts, Jones Day, and U.S. Trust Company of Texas.

We are especially obliged to the lenders who have generously shared works from their collections to help make this exhibition possible. And we owe a debt of deepest gratitude to the eleven participating artists whose creative contributions are the foundation and splendor of this project.

John R. Lane
The Eugene McDermott Director

An Introduction

Suzanne Weaver

After the all-day meeting of the advisory committee for *Come Forward: Emerging Art in Texas,* I was having dinner with one of the members, Aaron Parazette, a highly respected artist and teacher at the University of Houston, when he suggested that my co-curator, Lane Relyea, and I were "doing *Public Offerings* now." A 2001 exhibition at the Museum of Contemporary Art, Los Angeles, *Public Offerings* was conceived to be an examination of influential art schools in the U.S. and abroad, yet it evolved into a presentation of the break-through works of many well-known artists. Aaron's remark made me pause. It's one thing to look back, to review an artist's career, which includes several exhibitions and bodies of work, and identify the artist's turning-point work. It's another to try to select an artist's first critically successful or resolved body of work when he or she is still in graduate school or has recently graduated.

The arena in which I am working is continuously changing, and has changed especially since the 1990s (a period of major expansion of the number of artists receiving M.F.A. degrees)[1], when I began my curatorial career as a National Endowment for the Arts intern at the Indianapolis Museum of Art. Besides being an arbiter of taste, as Alexander Dumbadze identifies the profession of curator in his thought-provoking essay for this catalogue, I sometimes play a role in an artist's career and in establishing the value of his or her art. As a museum curator, my position in the art system—the interdependent trio of art schools, galleries, and museums—is key. Although there is plenty of room for reform and refinement in that system, it still offers immeasurable opportunities for nurturing creativity and fostering important ideas about art, past and present, and about the times in which we live. So my first reaction to Aaron's remark, "Oh, my God," quickly turned to "Hell, yes."

I was never concerned that Lane and I would have trouble finding artists who are making smart, ambitious work. Throughout Texas, there are numerous venues for motivating and enriching artistic practices: excellent universities, colleges, and art schools such as the School of Visual Arts, University of North Texas, Denton; and the Core Residency Program, Glassell School of Art of the Museum of Fine Arts, Houston; ArtPace Artist-in-Residence Program (San Antonio); superb museums, both the encyclopedic institutions like ours and the *Kunsthallen* like the Contemporary Arts Museum (Houston); nonprofit exhibition spaces; commercial galleries; and supportive art communities in Houston, San Antonio, and other cities and towns.

Before we set out to make studio visits, Lane and I decided on two requirements: The artists would have a certain level of education and live (and continue to live for awhile) in Texas. We wanted to find artists whose work, although young, revealed clarity, conviction, and commitment; work that was connected to the larger dialogue of art, had assimilated and moved beyond influences and inspirations. We found a number of artists who were making strong work and who fit within our conceptual framework. Lane and I also agreed that a huge, unwieldy, everything-but-the-kitchen-sink exhibition would not serve a meaningful purpose. With a smaller selection of artists given the opportunity to present a whole body of work or a newly created project, there would be deeper opportunities for examination of and engagement with the art.

Come Forward is a focused and dynamic exhibition, a gestalt, the whole greater than the sum of its parts. With its unique, innovative catalogue (which includes in-depth analysis of the work of the eleven artists in this exhibition and a discussion of challenging ideas facing emerging artists everywhere), a collaborative exhibition design, and enhancing programming, *Come Forward* is a richly layered experience with relevance and resonance beyond the Red River. It is a fascinating picture both of an emerging generation of artists and of the vigor and vitality of art in Texas. Not only does this group of artists provide a reminder of the high quality of art being made here, it also indicates a bull market in Texas art futures.

I am not egotistical enough to say that these eleven artists will define the generation of artists in Texas, say, thirty, twenty, or even ten years from now. (Of course, there will be artists who leave while others move in.) Besides, Texans often hold claim to certain "Texas artists" even if they haven't lived here for years (think of Robert Rauschenberg, Sam Reveles, Christian Schumann, and even Donald Judd, who purchased a parcel of property within the town of Marfa in 1973 and lived there until he died in 1994). But I do know that each of these artists is the real thing. Their art, to borrow De Kooning's declaration about painting, is a way of life.[2] I am not taking bets, but I am sure that some of the artists in *Come Forward* will go on to be established and even to become subjects of museum retrospectives.

I want to express my appreciation for Lane Relyea's intelligent, impassioned, and clear essay on the practices and strategies of these artists and the current situation in which they produce and present their work. I feel very fortunate to be his co-curator. My gratitude goes to each of the artists in *Come Forward*, for their inspiring talent and commitment. Working with them, and with Lane, was like auditing a few semesters at one of the best art schools in the country. It was an immeasurably rewarding experience.

Notes

1. "It was only in 1960, though, that the College Art Association finally approved the M.F.A. as the single 'terminal degree for graduate work in the studio area.' Thirty-one new M.F.A. programs opened during the decade of the '60s; another forty-four in the '70s. During the first half of the '90s, the period [*Public Offerings*] examines, more than 10,000 M.F.A.s were awarded in the United States." Howard Singerman, "From My Institution to Yours," *Public Offerings* (Los Angeles: The Museum of Contemporary Art and Thames and Hudson, Inc., 2001), p. 283.

2. Barry Schwabsky, "Notes on Performative Art," Part II, *Art/Text* 63 (November 1998 - January 1999), p. 75.

Growing Up Absurd

Lane Relyea

This exhibition pivots on what now seems a modern yet very old and fragile idea. It's the idea of how a young artist emerges. The criteria used to select this show's participants have focused on not only the quality of what they make but also the time at which they make it. A climactic moment has been reached in a dramatic narrative about self-discovery that is so conventional, so fundamental to our notions of art, it can almost be recited by heart. Each artist here is assumed to be presenting his or her first important body of work—each, so the story goes, has turned a corner, has crossed over from impressionable student to self-possessed author, has soaked up and converted myriad influences from years of research and study into a fully realized, singular statement. The plotline has to do with more than the learning of a métier, the successful indoctrination into a discipline and craft, as eighteenth-century narratives centered on the old academy would have it; it has to do with a personal quest, a tale of achieving individuality more in the manner of the nineteenth-century Bildungsroman, or life story. A century and a half of writing about modern art and artists has made overly familiar the basic claim this exhibition makes for its young participants: They have found themselves, are able to speak in their own voices, sign their works in their own hands. No longer just spectators to the history of art, they are themselves historical actors, suddenly artists in their own right, and now they relate the tradition of art as if it were their own story to tell.

That we currently live in a transitional moment, a historical in-between zone, can be gauged precisely by how such a major feature of the belief system underlying our dealings with art can feel at once so intractable and no longer entirely convincing. There are plenty of reasons to doubt the story I've just rehearsed. For one, it makes the phenomenon of how artists emerge heavily symbolic—there is a deep meaningfulness, a rich interiority to be plumbed in the notion of self-knowledge and the journey required to attain it. But this very depth is what much recent discussion about art has tended to flatten out.[1]

Increasingly, whether in the popular press, academic journals, or art magazines, attention has been trained on the business of art, its economics, sociology, and institutions: Articles dwell on art stars, incomes, career moves, lifestyles; on art fairs, museums, *Kunsthallen;* on which dealers and curators are currently organizing which artists into which exhibitions. As a business, art gets treated not as story but as system, and in place of themes, plot twists, and decisive moments, all of which call for interpretation in depth, there are now interlocking operations and transactions that lend themselves more to being charted laterally, as if on a map.

The operations by which artists emerge are also included on such a map. For a few years now art schools have been a central topic of conversation, and the way they get talked about has centered on the crucial role they play in the efficient running of the art biz. In this context artists emerge by passing through a bureaucratic obstacle course of admission committees, faculty critiques, and thesis shows. Today's typical emerging artists (including a number in this exhibition) brandish resumes listing long series of institutions, from reputable graduate schools to competitive residency programs to the kind of project-room spaces at galleries or (increasingly) museums that have recently become ubiquitous. The sequence is now so common that it's hard to pinpoint

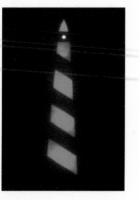

Marshall Thompson
Untitled (lighthouse), 2001
Birch, acrylic, electronics, and laminated paper
Courtesy of the artist and Angstrom Gallery

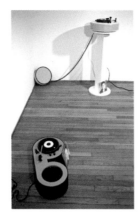

Brad Tucker
Singles, 2002
Wood, fabric, turntable
parts, speaker, 12 seven-
inch acetate records,
2 customized turntables
(one with built-in speaker),
1 speaker, shelf with 12
record covers featuring
images of the 24 recording
artists (1 per side) Courtesy
of the artist and Inman
Gallery, Houston

the moment of emergence; art undergraduates at the University of Texas in Austin or El Paso will tell you that they already *are* artists. And who can argue? The status is conferred by inclusion in the system, and as is often pointed out, art schools are now very much part of the system.

Given all this, an honest discussion of *Come Forward: Emerging Art in Texas* can't stick to the high road and explore how artists emerge as its only theme, as purely an idea or subject, peeling back all the layers of meaning such words as *idea* and *subject* imply. It's now too glaringly problematic that an artist's "emergence" is not just some private miracle a museum exhibition like this remotely contemplates and applauds but also something it does—a development the exhibition actively facilitates. Where does that leave the artists? It leaves them in a situation that's not necessarily better or worse than before, just radically different, with new possibilities and pitfalls to negotiate in the course of making compelling art (including the difficulty of newness itself, since old methods and terms seem inadequate and new ones are still being formed).

One way to characterize this situation is as a shift—for both artist and art work—from a private to a more public mode of existence. Because of the endless crits with faculty, visiting artists, and fellow students that now constitute the bulk of art school curricula, as well as the shows in which graduate and residency programs culminate, the study and training required to earn the credentials of an artist take place more and more in front of an assembled audience. Indeed, the promise of graduate schools and residency programs today is to provide gallery spaces and keen onlookers—and not just the onlookers that come with visiting-artist programs and class crits: Over the last three years the graduate programs at Columbia, Hunter, CalArts, and other schools have advertised their thesis exhibitions in *Artforum*. Graduation has become a publicity event, a photo op or chance to make a glossy sales pitch, as

student artists are "emerging" with not only a degree but also some prime ad space in a leading trade journal.

Schools also provide equipment, namely the video decks, projectors, and monitors that have come to dominate art exhibition. Finally, more and more institutions have arisen—think of San Antonio's ArtPace or Houston's Rice Gallery—that not only acknowledge the worth of existing art objects by arranging for their public display but also contract and underwrite the work's very production. Here public institutions displace the private studio as the site where art gets made.

The consequences of such changes extend well beyond institutions and their manipulations of otherwise innocent art. Indeed, they are affecting the art itself, altering its very nature. One can argue that the emergence of a more public situation corresponds to a move away from the poetics of the art work, the mysteries of the object as thing-in-itself, and toward art's more rhetorical side, toward the question of what kind of effects it registers on its audience. That is, art works generally have become more outer- than inner-directed ("eloquence is heard and poetry is overheard" was how John Stuart Mill famously distinguished between rhetoric and poetics).[2] No doubt contributing to this shift (or symptomizing it) has been the dissolution of painting and sculpture as disciplines whose medium-specificity encouraged historically and materially compounded objects. Also promoting this reorientation is the now standard protocol experienced by student artists, the heavier foot-traffic through their studios and the endless onslaught of crits; all these developments endorse the notions that art works reach completion not internally and materially but externally through contact with a public, and that the artist's role at that moment of fruition is as spokesperson, someone who justifies the work by turning his or her back on it to face the audience as jury.

There are plenty of examples in *Come Forward* of art works turned outwardly, addressing themselves directly to the viewer. Arguably this approach is the closest thing, beyond "emergence," to a shared theme, an umbrella under which this exhibition can place its otherwise disparate inclusions. The logos

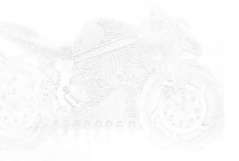

Irene Roderick
*Façade Series:
Motorcycle 1*, 2002
Latex primer on
architectural film
Courtesy of the artist

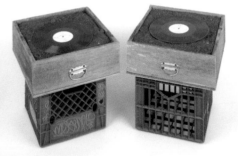

Robert Pruitt
THA Ten Commandments, 2002
Wood, dirt, vinyl, milk crates
Courtesy of the artist

Adrian Esparza
Round and Round, 2002
Acrylic on plywood
Courtesy of the artist

out the physical facts of painting, apparently exploring in their own right different methods of paint application — spraying, drizzling, stroking on with a brush. But the results end up reversing his predecessors' iconoclastic aims. Di Stefano's processes themselves appear acutely image-conscious, even cosmetic; often they're enacted in blatantly seductive color combinations such as warm pink against black; or brushstrokes will be isolated on their rectangular field so tastefully as to look spotlit on a stage. Sometimes brushstrokes are *too* isolated, a few daubs orphaned in the corner of an otherwise monumental canvas. Connotations, narrative overtones, even sentimentality creep in where they least belong. Paintings that at first seem to possess nothing but objective information suddenly appear to be grandstanding, playing to the crowd.

Still, in Di Stefano's work an apparent desire for public adulation never completely supplants, but rather must coexist with, a coldly clinical, technophilic anonymity. It may sound like a great boon that the legendary alienation suffered by young artists is at last finding relief through increased opportunities to show and interact with audiences; and yet if the growing integration of universities, residency programs, and museums into the contemporary art world has succeeded in bringing working artists back into the social fold, it's not in the manner many had hoped. A dated conception of modernism once provided alienated artists with a sense of place within their own separate history (a history built on an inward-turned investigation of the materials and techniques peculiar to art making); now the artist is placed — by graduate and postgraduate programs, more than anything else — within a specialized field, one that encompasses not just the classroom but the entire network of magazines, galleries, and so on. The ability to function and contribute professionally is the key to success in both the crit and the marketplace. Professionalism replaces claims to autonomy; one form of separateness gets exchanged for another. Meanwhile, patronage grows colder and more faceless the more institutional and corporate it becomes. The die-hard support, even companionship once offered by the individual patron or dealer or critic-champion seems to have been eclipsed by the turnstile mechanisms of a multinational business complex, to which artists now submit themselves as free agents. Lawrence Alloway, who was always keenly perceptive of the growing institutionalization of art, remarked as early as 1964 that

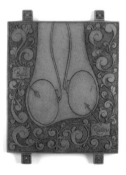

Chris Sauter
Minotaur Testicles, 2002
Tooled leather, tacks
Courtesy of the artist

and banners featured in Marshall Thompson's and Brad Tucker's ensembles; the mural format and often ceremonial iconography that Irene Roderick relies on; the similarly ceremonial objects, like microphones or headdresses, with which Robert Pruitt gains for his work a suggestion of performance; even the flaglike appearance of Adrian Esparza's wall-mounted throw rug — all represent formal building blocks, a general infrastructure of public address. Tucker's sculptures often double as visual art and audio speakers; Juan Ramos, like Tucker and Pruitt, enlists language and band culture in his work to counter the visual address of the audience with an audio address of its own. Brent Steen's and Joey Fauerso's images confront the viewer literally face to face. Chris Sauter's spectacle comes complete with arena and bleachers.

Even the painstakingly crafted, materially impeccable paintings of Augusto Di Stefano reveal a strong rhetorical bent. Di Stefano's point of departure seems to be the process-oriented work of such 1960s painters as Robert Ryman, in which canvas is made to function less as the bearer of an image than as the record of an operation or event. Di Stefano, too, straightforwardly lays

Joey Fauerso
Bubba, 2002
Oil and acrylic on paper
Progressive Corporation,
Cleveland, OH

Augusto Di Stefano
Working Title, 2002
Oil on canvas
Collection of Jeff
and Nancy Moorman

"...[O]nce discovery used to carry with it certain assurances and safeguards for the artist and his public; now discovery is a form of classification with no reduction of the risks and solitude artists work in."[3]

Growing up in public, then, is only part of the story behind today's art; there is also the artist's insecurity about how that public should be addressed, whether it can be counted on, and for what; there's an uneasiness about how to connect, what to say, and in what way to say it, a simultaneous desire and reluctance to be intimate, at home, sincere. Such insecurity also finds various forms of expression in *Come Forward*. One path into (or around) the problem is represented by Robyn O'Neil's and Marshall Thompson's work, which seems to long for an innocence, naiveté, and privacy defined precisely as a retreat from the jaded erudition of college-trained, professional art. Both artists trade in an iconography of adolescent fantasy — their dinosaurs, action figures, and high-seas adventurers are images that daydreaming high-schoolers might doodle on their Pee-Chee folders to escape the teacher's drone (possibly an association behind O'Neil's preference for notebook-size paper). There's a genuine sympathy for the ideal of unschooled creativity in both artists' work, but also a deliberate and poignant sense of resignation; neither of them can manage to convey that ideal except through a thoroughly conventional, even shopworn language, the all-too-familiar and public signs of private dreaming. Thompson, in particular, plays up the element of allegory, which undercuts with its weary foreknowledge his intimations of exciting voyages into an exotic beyond. In both artists' work the viewer confronts not fresh discoveries of the fantastic so much as venerable emblems by which the culture has long encoded the theme of discovery.

A number of other artists in the exhibition similarly search for ways to split the difference between a public they feel is too faceless and a privacy that, for better or worse, is irretrievable. Various attempts are made to rehabilitate the cold formality of the art institution by filling it with works evocative of a warmer, more personable context, a place where tightly knit groups — friends, extended families, subcultures — might convene. Esparza's work, for example, derives from the kind of anonymous craft labor (pattern-making and sewing) that is linked to the intimate domestic realm (this holds true, though more ironically, for Roderick's patterning as well). Sauter employs diagrams outlining sexual reproduction (a "group" activity at its most private), which are made to bridge the spheres of clinical science, family life, and pop entertainment. But the most obvious example of this humanizing approach is provided by Brad Tucker, whose layabout art seems to shy from spotlight and pedestal in favor of the more modest role of appointing and decorating space, as if to provide the backdrop for a social event. What kind of event is made clear by the record players, skateboarder paraphernalia, and confidential name-dropping, Tucker's main motifs, which together transform the gallery from sterile institution into youth-culture oasis. Here, supposedly, is a public milieu in which one can relax, speak both openly and confidentially, and (to paraphrase Mill) be at once heard and overheard.

The private self strikes a far more conflicted public pose in the works of Roderick and Pruitt. Despite their vast disparities, both formal and personal (they represent, respectively, the oldest and youngest participants in the exhibition), the two are informed by a politics centered on notions of identity and its socially embattled formation. More than anyone else in this company, Pruitt makes the most of found objects, using them to import a no-nonsense gravity from the real world into his art. Not content to leave reality as is, however, he partially transforms it by coaxing metaphor from its literal character. A found milk crate filled with soil doubles as a DJ's turntable; a microphone affixed to the handle of an old vacuum cleaner turns its filter bag into a powerful lung, albeit one choked with dust. The result is a kind of magic realism, which simultaneously acknowledges and transcends gritty circumstances.

As for Roderick's work, it could be described as a series of stunning rhetorical façades, each image immediately communicating to the viewer a sense of visual purity and unity despite its being built up of all sorts of zigzagging contradictions. Large-format, centered, iconic imagery and a color palette restricted to white at first conceal a motley mixture of source materials, drawing methods, stylistic traits, and otherwise tangled significations: Repeated circles read as both rigorous geometry and frivolous polka dots; hectically poured skeins evoke both Pollock's heroic process and cake decoration; an idealizing and rationalizing design sense melds with a scatological indulgence in drooling materials; emotional effects range from blissful composure to brutal restraint to manic

outcry. Roderick leaves such tensions unresolved, making all the more achieved the impression of unity that comes through. Her monumentalism seems to gain credibility as personal (read: political) statements precisely for being so self-conflicted and internally diverse. Contradictions don't negate the overall power and persuasiveness of such statements but only articulate them more broadly, rendering them experientially more capacious.

Brent Steen supplies the most glaring example of an artist whose work turns toward a public it simultaneously embraces and distrusts. The large photograph of an almost life-size Steen backed into a corner while going eye-to-eye with the viewer, defensively titled *I Don't Know What To Do for You*, could serve as a frontispiece for this entire exhibition. The theme of connection — the urgent need for it, the ultimate frustration of it — runs through all his works, but it is given a perversely ironic twist in the video *it's okay...okay*, 2001. Here, at last, connection seems at hand. Steen choreographs sentimental vignettes (isolated figures strolling through an evening downpour or an empty stadium) to equally sentimental background music, all filmed in slow-motion pans and zooms, apparently in imitation of Hollywood at its most cloying. Such insistent tugging of the heartstrings guarantees the viewer's tight identification with the filmic representation, while what the film represents is nothing other than identification itself: The two figures on screen prove actually to be one. Steen, the actor, has created a life-size replica of himself from the neck down, a limp dummy that he wears like a cape over his shoulders, making his head appear to be sprouting two identical bodies. It's a strange image, a striking way of rendering the idea of self-absorption. And yet, though it may be riveting to watch an image of Steen riveted to his double, there is at the heart of the video a nagging incompleteness; the connection between audience and artist is never made. Steen's communion with himself is so total it shuts out any awareness of a larger social field, including the immediate one inhabited by the viewer. The artist hides within himself—and that is, poignantly, what he so generously crafts for the audience to enjoy.

Like Steen, Ramos and Fauerso emphasize the complexities inherent in the give-and-take between artist and viewer. But whereas Steen collapses such negotiations, the latter two draw them out. Different points of view are brought into a dialogue whose con-tinuation depends on their never reaching too seamless an agreement or pulling too far apart. In Fauerso's paintings, for example, the exchanging of looks between art work and viewer gets analyzed down to its root coordinates. Friends and family having their portraits rendered sit in an attitude more playful than tense or passive; they put their fingers to their mouths in an ambiguous gesture, part hand signal, part oblivious thumb-sucking. This seeming surrender to the distractions of their own bodies roots the sitters more firmly within themselves, even though they also press forward toward the viewer (Fauerso's decision to dress them in black helps to flatten their bodies, logolike, against the picture plane). Such two-sidedness finds elaboration in Fauerso's more abstract paintings, which view patterns and designs from different angles, depicting both plan and elevation. The results even the odds in the wrestling match between

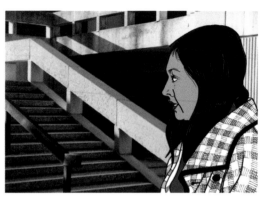

Juan Miguel Ramos
Sofia's Map, 2001
One of seven digital prints
Courtesy of the artist

Juan Miguel Ramos
Sofia's Map, 2001
One of seven digital prints
Courtesy of the artist

Brent Steen
Hugging the window, 2002
Pencil on canvas
Courtesy of the artist and Inman Gallery, Houston

seer and seen: Fauerso's subjects both submit to and resist being captured as images for others; they are centered simultaneously on their own gravitational axes as well as the viewer's sight lines, standing somewhat independently while also inviting sympathy and connection. Nothing and no one is hidden from sight or fully surrendered to being seen; both vision and its objects are prioritized rather than sacrificed one to the other.

Ramos, too, practices a subtle diplomacy in how he puts images of friends and acquaintances on display, rendering them in a manner that combines the casual air of snapshots with the reverence of formal portraiture. Each image starts as a personal photo — one that betrays an intimacy between cameraman and subject — which Ramos enlarges and embellishes in a graphic style reminiscent of comic-book art. Such alterations elevate the transient, prosaic character of the snapshot to the timeless, larger-than-life stature of the stage actor. Moreover, Ramos doesn't just capture likenesses but attentively listens to his characters as well, providing them with word balloons in which to tell their stories. His protagonists no longer stand as mere objects to be viewed; rather they are empowered to address each other and the viewer in turn. Topics of conversation (including local rock heroes and ancient Mayan lore) often overlap, and as they do, a kaleidoscopic image of a shared social world comes into focus, one that allots equal time to each of its inhabitants so that no one point of view holds sway over any other. Motivated by the complementary impulses of curiosity and respect, Ramos elaborates public dialogue into an egalitarian utopia, enacting master narratives without slaves. Here, at last, is a public realm in which art can feel at home, since art and public engender one another. Here, at last, dramatic momentum is restored to the theme of emergence — albeit no longer the emergence of the artist so much as that of a world in which artists can act, a world they can express, and that expresses them, a world they can perhaps even change.

Notes

1. See, especially, Howard Singerman, *Art Subjects: Making Artists in the American University* (Berkeley, CA: University of California Press, 1999); also Howard Singerman, editor, *Public Offerings* (Los Angeles, CA: Museum of Contemporary Art, 2001); Andrew Hulktrans, "Surf and Turf," *Artforum* 36, no. 10 (Summer 1998), pp. 106 - 113; and Deborah Solomon, "How to Succeed in Art," *New York Times Magazine* (27 June 1999), pp. 38 - 41.

2. Mill quoted in Timothy Gould, "Utterance and Theatricality: A Problem for Modern Aesthetics in Mill's Account of Poetry," Ted Cohen, Paul Guyer, and Hilary Putnam, editors, *Pursuits of Reason: Essays in Honor of Stanley Cavell* (Lubbock, TX: Texas Tech University Press, 1993), p. 133.

3. Lawrence Alloway, "New Talent USA: The Past Decade," *Art in America*, no. 4 (1964), p. 21.

Are You Experienced?

Suzanne Weaver

We must return to the *Lebenswelt*, the world which we meet in the lived-in experience of the world.

Maurice Merleau-Ponty

In the twenty-first century, society has moved from the industrial to the postindustrial age, from the manufacture of objects to the production of services and information. Although neither desire for the latest thing nor production of it — whether a car, designer suit, or computer — has slowed down precipitously, our economy continues to be based on technology and information and the creation of intangible things. The speed with which information is electronically delivered is changing our perception of time and space. More important and dangerous to healthy social relationships, according to French technology theorist Paul Virilio, our televisual/cybernetic/virtual culture is causing a split of ourselves between two separate worlds — virtual and real — and a loss of orientation to the other and to our surroundings.

One response to this splitting of self and loss of orientation appears to be society's increasing desire for real, somatic experiences. (Another is internet addiction disorder, or IAD, and attendant support groups for addicts.)[1] Of course, the partakers of these real experiences often expect them to be entertaining, a development that has been widely explored by exhibitions such as *Let's Entertain* (organized by the Walker Art Center in 2000) and books such as Neal Gabler's *Life: The Movie (How Entertainment Conquered Reality)*.[2] Whether the experience is of low or high culture, reality television shows or life-as-it-is-happening-now films shot with hand-held cameras, *World Wide Federation of Wrestling* or *Live at Lincoln Center*, it must be both utterly real and entertaining.

Within the contemporary art world, especially in the last decade of the twentieth century and the beginning of this one, artists working in all media (not just video and installation) are exploring experience — their own and their audience's. For the philosopher of phenomenology Maurice Merleau-Ponty (1908-1961), experience "as it occurs in and through the perceiving body"[3] is crucial to human knowledge. The body, which thinks and perceives, according to Merleau-Ponty, should not be viewed solely as an object or material entity of the world. There is no distinction between the act of perceiving and the thing perceived; inside and outside as well as mind and body are inseparable. "My body is a movement towards the world, and the world my body's point of support."[4]

Merleau-Ponty's idea of embodied experience, that our body is not in space but inhabits space and time,[5] and his statement "there is no inner man, man is in the world, and only in the world does he know himself"[6] resonate in the work of the eleven artists in *Come Forward: Emerging Art in Texas* — as it did for artists in the 1960s, finding expression especially in Minimalism and Donald Judd's idea of specific objects or real, actual space. The art of the 1960s provides a fertile field of influences, ideas, and approaches to explore for the artists in *Come Forward* — perhaps not only because of the decade's emphasis in their university and art school training, but also because all these artists are children of baby boomers except Irene Roderick, who is a boomer herself. (In a recent conversation, Dave Hickey gave me a good explanation for the reasons young artists are looking at '60s art: "It's the only art around. For example, where's anyone going to see a Barbara Bloom installation?")

Several of the artists in *Come Forward* (like many of their peers outside Texas) produce work that also draws on the conceptual, process-oriented, and performance-based art of the 1960s and 1970s. But without the charged social, political, and cultural context — the civil rights and student movements, the Vietnam War, the assassinations of John F. Kennedy, Martin Luther King, and Robert Kennedy, for example — artists working today seem not to be driven by the utopian belief in or "aggressive self-certainty" of the power of art to transform art and society.[7] Some of the *Come Forward* artists are motivated by socio-political concerns and dominant aesthetic conventions — Irene Roderick offers a feminist critique; Juan Ramos and Robert Pruitt, respectively, address stereotypes of Mexican Americans and African Americans generated and perpetuated by the media; and Robyn O'Neil challenges the popularity of video —

but they explore these issues subtly, indirectly, and even playfully. As New York-based art critic Barry Schwabsky points out in his essay "Notes on Performative Art," "[T]oday, we know something about those forms of art (Dada cabaret, the Happenings of the sixties, or conceptual activities of the seventies) that weren't, couldn't have been known when they were new, which is that they would neither transform art completely nor be left behind by it; they remain marginal, yet in their marginality lies their continuing power to fascinate....."[8]

Robyn O'Neil's finely detailed pencil drawings of dinosaurs, boats, and middle-aged men are acts of "rebellion," says the artist. A return to picture-making, which she considers "the reason for making art in the first place,"[9] these drawings, like illustrations in old-fashioned children's books, are an affront to the perceived superiority of video in art schools, museums, and galleries. They are also an avenue down which O'Neil and her viewers can return to early childhood experiences through images that can still conjure up mystery and awe. Although straightforwardly depicted, the dinosaurs, even when aggressive, seem melancholy; some exude a quiet desperation.

Like her dinosaurs, O'Neil's boats, with no one aboard, even at the helm, are anthropomorphic. Their actions in the water—speeding away, cutting through big waves, colliding—become metaphors for human behaviors, attitudes, and events. The artist's other current subjects, inspired by B-movies, including the contemporary movies on the Lifetime network, are middle-aged, leisurewear-clad characters named Miami Dave, Diamond Leruso, and Eddie. Shown skiing, running, or working out in various locales, they pursue happiness in the face of accidents and natural disasters. Like the deceptively ordinary territory explored by film director Sam Mendes, particularly in *American Beauty,* the absurd world of O'Neil's awkward and often silly men presents the human paradox of our awareness and our alienation from life as it unfolds.

Juan Ramos also uses a drawing technique associated with childhood, that of comic books, whose power he taps to invent, frame by frame, a story with emotional and psychological consequences. His highly sophisticated drawings, striking suites of richly colored iris and digital prints, and black-and-white photocopies of drawings with text, plumb the immediacy and accessibility of the comic book's vernacular language. Nonlinear, undidactic, his work portrays a Post-Chicano[10] world in which Mexican and American cultures meet and mix; it's a world where a sense of identity, location, and place, of reality itself, is being transformed. Although his drawings of people in *Mirror Maps, Sofia's Map* (in which figures in profile refer to pre-Colombian art), and *Ghost Story* are based on the photographs he has taken of friends and family, his work, says the artist, should not be viewed as traditional portraiture but rather as "civic portraits" meant to mirror and describe a place. *Ghost Story,* for example, is a series of first-person accounts, in English and Spanish, of the local San Antonio legend

of the ghost tracks, which are located on the south side of the city. As each person retells the story, changing it to fit his or her experience, the series becomes a metaphor for collective memory and changing identity. In the black-and-white *Secret City* series, added text or fragments of conversations offer alternative narratives to mainstream notions of Mexican Americans and their way of life. (Ramos, who in his early twenties played with the Austin punk band Glorium, which toured with Fugazi, exemplifies the difficulty in placing Mexican Americans into easy categories.) Combining drawing and photographs, the hand and the mechanical, subjectivity and objectivity, Ramos questions viewers' assumptions and notions of reality, as if to ask: "What makes the place, the individuals, or the stuff around us? Which is more important? Which is more real?"

Like Ramos, Joey Fauerso uses her own photographs of friends and family in her work. For each painting in *Come Forward,* Fauerso gave her "sitters" (she often works with her sister Elizabeth, which "provides certain kinds of emotional and narrative attachments" according to the artist) the simple directive to perform a highly charged, symbolic, and often private act—finger sucking. From work to work, this particular gesture varies, suggesting different attitudes, emotions, and thoughts to the viewer being confronted by them, setting up a dynamic, interdependent relationship between work and audience. In *The Visible and Invisible,* Merleau-Ponty calls this intertwining of the subject and object, self and work, a *chiasmus* or *chiasma.* "Between my body looked at and my body looking, my body touched and my body touching, there is an overlapping, or encroachment, so that we may say that things pass into us, as we into things."[11] To investigate further this relationship between the subject and object, Fauerso creates a number of small pencil drawings, circular in form, that are abstractions or diagrams of the movement between image and viewer.

Fauerso's rough yet beautiful figurative paintings are conceptually closer both to Chuck Close's investigative use of the figure to explore systems and Hans Haacke's process-oriented work in the 1960s than to work by artists focused on creating an image, a signature style. Fauerso's intuitive searching, manifest in "lots and lots of paintings, drawings, and photographs," is not about "making something so much as it is about finding something," says the artist, echoing Robert Motherwell: "We are involved in 'process' and what is a 'finished' object is not so certain."[12]

Irene Roderick also delves into the nuanced intertwining of the viewer and the work. Through a complex layering of contradictory feminine and masculine signs, Roderick's large-scale work (white latex paint on translucent, vellumlike architectural film) depicts architectural elements and images of motorcycles to offer a subtler feminist critique than the earlier work she produced in graduate school.[13] Creating a sense of both fluidity and structure, the thick, curvy white paint is repeatedly added to and scraped off of precisely calculated,

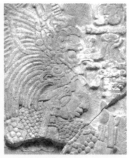

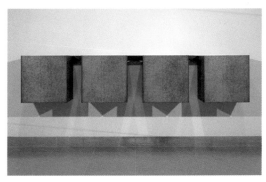

Donald Judd, *Untitled*, 1965, galvanized iron and brown enamel on aluminum, Collection of Robert and Marguerite Hoffman, © 2003 Donald Judd Foundation/Licensed by VAGA, New York, NY

"mathematically mapped" macho forms. The repetitive, labor-intensive process of pouring, adding, and scraping evokes both "women's work" and Jackson Pollock's drip method.

Roderick's work also points to Donald Judd's idea of "specific objects," three-dimensional works that Judd described not as painting or sculpture but as "open and extended ... a space to move into ... real space."[14] Roderick takes Judd's idea further by heightening the complexity of the space the viewer inhabits. The whiteness and translucency of the pieces expose the white wall on which they hang, flattening out the forms, making the work part of the architecture, shaping the space. By physically moving in front of the work, the viewer senses an "interplay of shadow and transparency in the same way he or she experiences minimalist forms." In essence, interweaving the masculine and feminine, the physical and conceptual, Roderick has found a way to challenge her own and the viewer's relationship to power and beauty, putting forward for questioning the proposal by critic, painter, and teacher Jeremy Gilbert-Rolfe that "beauty is feminine, neither representing nor possessing actual power."[15]

Power is also an important theme in the work of Austin artist Robert Pruitt. Like many of the Italian artists in the 1960s group known as *arte povera*, such as Michelangelo Pistoletto and Luciano Fabro, whose sculptural objects address social and cultural issues, Pruitt recycles scraps and discarded materials that carry symbolic and metaphorical weight in work that explores the contemporary African American experience in an undidactic and playful way.

One way of interpreting the image of a line of African slaves spiraling down the drain of a white porcelain sink is as a visual metaphor for the migration not only of a people but also of myth and memory.[16] For Pruitt, spiritual and psychological damage migrated right along with the music and narratives that African slaves carried into the controlling and limiting "white supremacists'

patriarchal system" of America. In an interview, David Hammons, an African American artist who gained critical attention in the 1960s and whose aesthetic sensibilities are comparable to Pruitt's, spoke of this damage as shock. "I think it's because we saw our families separated on the auction block..." he said. "When these kids are born today all this shock is still with them ... These kids don't know why they're so wild, but there's born-in stress, long lines of stress."[17]

Pruitt's sculpture *babee, yo rootz R showin* (a wonderful interplay of title, material, and image), incorporates found wood, African American women's hair weave, and barbed wire to comment on African American ideas of beauty, descended from African traditions but filtered through and influenced by the stereotypes "generated by a mostly white, corporate-controlled media."[18] The combination of worn and discarded objects in his performance-based sculpture *me and this mic is like yin and yang* (a microphone and vacuum cleaner) and installation *THA Ten Commandments* (vinyl records, dirt, and milk cartons) creates an atmosphere of loss and alienation. This melding of seemingly disparate elements can be compared to the mixing of found sounds and samples of other recordings that characterizes hip-hop, a passion of the artist's.[19] Arising out of the tough, crime-ridden South Bronx in the early 1970s, hip-hop gave a searing voice to the "damage" Pruitt's work subtly explores.

Adrian Esparza's drawings and sculptural objects, process-oriented and alluding to body and home, have a surrealistic, even hallucinatory quality. They are informed by his interest in the Big Bang theory of the origin of the universe as well as the theory of rhizomes as developed by French philosopher Gilles Deleuze and Lacanian psychoanalysist Felix Guattori in their provocative book *A Thousand Plateaus;* a rhizome is a structure always in the process of formation and deformation, wandering away or spouting from its original organ, existing as an independent part only to regroup or reform, creating a synthesis. Esparza's patterns, drawn on a full-size bed sheet or quilt made from pillowcases, appear to be in an evolutionary state, simultaneously coalescing as they come apart. Hanging on the wall, a Mexican serape unravels thread by thread, seeming to dissolve, reweave, and transform into the new object next to it (a geometric, striped painting?) Parts of all-white ceramic rabbit, clown, and bird figurines (the type Esparza's grandmother taught prisoners at an El Paso detention facility how to make) are combined

Robert Gober, *Untitled*, 1989-1990, wax, cotton, leather, human hair, and wood, 11 3/8 x 7 3/4 x 20" (28.9 x 19.7 x 50.8 cm), The Museum of Modern Art, New York. Gift of the Dannheisser Foundation. Digital image © 2003 The Museum of Modern Art, New York

David Hammons, *Head*, 1998, hair, stone, metal stand, The Rachofsky Collection, sculpture photographed at the Rachofsky House, photograph by Harrison Evans, © 2003 David Hammons, courtesy of the artist and Artemis Greenberg Van Doren, New York

into one object that is cartoony yet disturbing. These uncanny combined fragments recall Robert Gober's surrealistic reconstructions of everyday objects (sinks, beds, and urinals, for example), and, like Gober's modified objects, Esparza's altered figurines are closer to the world of dreams and memories. They also produce a subtle tension in the viewer who tries to read them in formal terms. All-white, casting little or no shadow, they seem to dissolve in dramatic, sinewy abstract lines, which barely carve out space; they shift from sculptural object to line drawing in air.

Although Chris Sauter's work makes no direct reference to Hans Haacke, his finely designed and crafted large-scale installations, layering aesthetic, biological, and cultural systems, are similar to Haacke's work of the 1960s and early 1970s, which used nontraditional materials to reveal the flux and transformation of physical or inorganic systems. With his multimedia bull-riding project, *Engaging the Minotaur*, commissioned for this exhibition, Sauter has refined his use of medium and processes to explore the intersection of the body and culture; of the real, or physical, and the constructed, or metaphorical.

Engaging the Minotaur comprises two major parts: a wood-paneled living room (with brown carpet from the artist's parents' house) raised up off the floor with two-by-fours, and an octagonal arena, whose furniture-quality bleachers have beautifully crafted, lathed legs made of white oak. The living room includes a recliner, two saddle-leather plaques hand tooled by the artist (one has a sensuous outline of testicles, the other of ovaries), a framed photograph of his parents wearing T-shirts, *Mom/Dad, Bull/Cowboy*, and a continuous-loop video entitled *2-step*[20] playing on the television. In the arena hang two projection screens showing a bull ride; one focuses on the bull, the other on the rider; when there is no action the camera is directed to the signs hanging on the fence. These hanging signs represent fictitious companies advertising "ideas related to culture (construction, clothes, nationality, and language)" and "ideas related to biology (seeds, plants, food, family)." The installation also includes a splayed-open leather Kevlar vest, the kind worn by bull riders for protection, embroidered with a family tree showing the occupation of each relative, and a flayed bull skin branded with the same family tree but showing only the gender of each family member. Two forged-iron brands—*X* and *XY*—lean against the wall opposite the bleachers. Loaded in myth, ritual, and narrative, bull riding, an eight-second competition, is not about the cowboy beating the bull (a score is evenly based on the performances of both the bull and rider). It is a metaphorical act of man and beast, the interweaving of their essences into a "Minotaur."

Sauter's process of making things—tooling the leather, embroidering, and branding—means to elicit the viewer's sense of his or her own body and convey a more proprioceptive than perceptive feeling ("proprioception being a 'sixth' sense, or the sense of ourselves inside our bodies").[21] Similar to the artist

Charles Ray's arduous process of creating his own clothes, as in his unfinished piece *Self-Portrait with Homemade Clothes* (1998), Sauter's labor-intensive methods in making these objects are an "attempt to understand and own the thing" while reinforcing the relationship between the psychological and physical.

Marshall Thompson is also interested in the interrelatedness of craft, materials, and meaning. Based on his experiences in metalworking, woodworking, custom-body and painting work on street Mustangs, his knowledge of electronics, and his collaborations with artists in the Good/Bad collective in Denton, Texas,[22] Thompson's "customized" sculptural tableaus and objects are finely made, kinetic, and performative. They are rich in nautical themes and images such as the sea, sailors, and ships — symbols and metaphors for childhood and adult memories, dreams, and desires. In each of Thompson's light boxes, a minimal image — a lighthouse, a ship, a treasure map — is framed in a plain birch frame. Primary colors and simple forms and materials found in the everyday world of signs, advertising, and tattoos make the work accessible and direct, but the lights' turning on and off alters the viewers' perceptions and expectations. As Proust once wrote, "There is no great difference between the memory of a dream and the memory of reality"; and indeed, with shifts of perception the intangible world of dreams and memories becomes tangible.

Brent Steen uses his own body and psyche in his unassuming, understated, often humorous videos, drawings, and paintings. Recalling Charles Ray's incorporation of himself in his sculptures and photographs, Steen's works such as *Hugging the window* (2002), a pencil drawing of himself with his back to the viewer, and his *What about a regular cry? (My conversation with Kurt Cobain)*, another simple, small pencil drawing (2002), propose psychologically charged, existentialist questions of authenticity. In the video piece *It's okay...okay*, the artist, with a white dummy hanging on his back (alter-ego? dead weight?), flies through the air, climbs over walls, and takes a walk in a park. The artist appears to be on a journey or quest. The strange and melancholy atmosphere of the video is reinforced by the soundtrack, which is composed by the artist's friend Kenny Woods.

Although Steen's video seems to meld the kind of awkward, sad situations of 1920s silent-era comedies featuring Charlie Chaplin, Buster Keaton, and Harold Lloyd with those of afternoon television specials for teens, it is more closely related to what have been called the "narcissistic" early videos of William Wegman.[23] Exploring the use of language in seven short reels made between 1970 and 1977, Wegman set up awkward, comic, and sometimes embarrassing narrative situations using himself, a surrogate such as his dog Man Ray, anthropomorphic objects, or a combination of the three. Like Wegman's work in front of the video camera, Steen's simple, searching, and at times comical gestures seem to embody Merleau-Ponty's contention that "existence is the very process whereby the hitherto meaningless takes on meaning."[24]

Charles Ray, Detail from *Self-Portrait with Homemade Clothes*, 1998, 35mm film in color with sound, © 2003 Charles Ray, courtesy of the artist and Regen Projects, Los Angeles, photograph courtesy of Joshua White

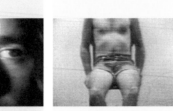

William Wegman, *Reel 1,*
1970-1972, Pocketbook Man
WI# 16711, Nosy WI#
16712, Stomach Song WI#
16712, 1970-1972, video,
© 2003 William Wegman,
courtesy of the artist

Morris Louis, *Delta Kappa*,
1960, acrylic on canvas,
Dallas Museum of Art,
Foundation for the Arts
Collection, given in memory
of Mary Seeger and John
William O'Boyle by their
children and grandchildren,
© 1960 Morris Louis

In Brad Tucker's installations and objects there are echoes of Richard Tuttle's and other process artists' work of the 1960s and early 1970s — Tuttle's floor drawings, Robert Morris's scatterings, Richard Serra's splashings, and Eva Hesse's hangings — which pushed the boundaries of painting, sculpture, and drawing. Although Tucker's work, made with everyday found and recycled materials, appears to have a slacker, low-tech, garage-band orientation, it is a rigorous investigation of painting, especially of the tenets of 1960s Colorfield painting.

What Tucker calls his "Yellow Pages" aesthetic is informed by the visual landscape of his Southern California roots — endless signs along endless freeways, the graphics on skateboards and the colors of the wheels (Tucker is an accomplished amateur skateboarder) — and by his later experience working in a sign shop in Denton, Texas.[25] Although his sign pieces, made of painted and unpainted wood, foam rubber, and latex, seem similar to Jack Pierson's word sculptures (without their sense of loss, abjection, and melancholy), Tucker's motivation is toward the "graphic and stylized appearance of sign lettering that suggests a painterly, even figurative image."[26] His performative *Drum Solos*, 2001, and *Singles*, 2002, comprising operable speakers, turntables, and recordings of friends, are made in simple shapes and primary colors that "act like paintings by butting against a wall or flattening themselves out on the floor," says the artist. This addition of content (the recordings) invigorates the surfaces of the work while energizing the viewer's experience of time and space.

Colorfield painting, for critic Barry Schwabsky in his essay "Color Field and Caro," "might now be better called an art of the factitious. Indeed, its stubborn attachment to illusion, even in the absence of representation, makes this art of the 'virtual real' that looked like the wrong turn thirty years ago feel surprisingly relevant."[27] Informed by a complex combination of processes and sources, high and low, Augusto Di Stefano's handsome, beautifully executed paintings, reductive and spare, embody the contradictory, critical analysis of Colorfield painting: flat versus spatial; optical versus tactile; and literal versus illusionistic space. His painstaking process of paint application (many coats of priming, sanded in between, several all-over applications of paint, and sprinkling, as well as drizzling), conveys duration of time as it also evokes the process-oriented oil-and-wax panels of Brice Marden and the white paintings of Robert Ryman. Di Stefano's addition of a thick mark or marks in a single line, cluster, or pattern in colors at odds with the color of the painting brings in narrative and associative elements. Intimacy intervenes on an impersonal field. These added marks, sensuous and animated, turn the work into an open-ended event or situation and toy with the viewer's notion of painting — is it object? image? activity?[28]

Merleau-Ponty, considering the inseparability of self and object, inner and outer, and ourselves and the world, points out that the study of the perceived always ends up revealing the subject perceiving. "Truth does not 'inhabit' only the 'inner man', or more accurately, there is no inner man, man is in the world, and only in the world does he know himself."[29] The work of the eleven artists in *Come Forward: Emerging Art in Texas* — whether O'Neil's simple, detailed drawings of dinosaurs, boats, and middle-age men or Sauter's complex layering of systems in his bull-riding project — reveals to us our experiences, past and present, and makes clear our reciprocal relationship with all things. Or, one might say — borrowing from the liner notes of Jimi Hendrix's *Are You Experienced?* — such art shows us that experience doesn't just make us older; "it makes us wider."

Brice Marden, *To Corfu*,
1976, oil and wax on canvas,
Dallas Museum of Art,
Foundation for the Arts
Collection, anonymous gift,
1976.23.FA, © 2003 Brice
Marden/Artists Rights
Society (ARS), New York

Notes

For the title of this essay I used the title song from the 1967 debut album of Jimi Hendrix and his band the *Jimi Hendrix Experience*.

1. In the fall of 2002, The Project, a cutting edge, experimental gallery in Harlem and Los Angeles, presented a group exhibition (*The Same Thing We Do Every Night*) that explored this recently recognized phenomenon of technology addiction.

2. "Our insatiable appetite for gossip, glamour and melodrama has turned all news events that dominate the media for months and conversations into a form of public entertainment. From the death of Diana, Princess of Wales, to the bombing of the federal office building in Oklahoma City, these episodes of life, or 'lifies,' have become movies written in the medium of life." Neal Gabler, *Life the Movie* (New York: Vintage Books, 2000), p. 5.

3. Frances Colpitt, "Systems of Opinion," *Abstract Art in the Late Twentieth Century*, edited by Frances Colpitt (Cambridge, United Kingdom: Cambridge University Press, 2002), p. 166.

4. "We must conceive the perspectives and the point of view as our insertion into the world-as-an-individual, and perception, no longer as a constitution of the true object, but as our inherence in things." Maurice Merleau-Ponty, *Phenomenology of Perception*, translated by Colin Smith (London and New York: Routledge Classics, 2002), p. 408.

5. Maurice Merleau-Ponty, "Spatiality and Motility," *The Philosophy of the Body*, edited with introduction by Stuart F. Spicker (Chicago: Quadrangle Books, 1970), p. 260.

6. *Phenomenology of Perception*, xii.

7. Barry Schwabsky, "Notes on Performative Art, Part I, *Art/Text* 60 (February - April 1998), p. 43.

8. Ibid.

9. This quotation and all other unattributed quotations are from my conversations with and e-mails from the artists in the exhibition.

10. "It's a theory term…Cesar Martinez told me that 'back in the day, Chicano Art was about a commitment to the cause. Nowadays everybody uses whatever term is convenient to serve their career.' Post-Chicano can mean after-Chicano; not Chicano…Post-Chicano art can be related to, derived from, or inspired by Chicano art, but it isn't Chicano art because our societal context has evolved…" Artist in conversation with author via e-mail, dated August 19, 2002.

11. Maurice Merleau-Ponty, *The Visible and Invisible*, edited by Carl Lefort (Evanston, Illinois: Northwestern University Press, 1968), p. 123.

12. Barry Schwabsky, "Notes on Performative Art, Part II," *Art/Text* 63 (November 1998 - January 1999), p. 75.

13. "The 'bimbos' necessarily went underground in order for the true content of the work, which is highly subversive and seductive, to rise (literally) to the surface. I am disturbed by the backlash against feminist politics, and therefore any work that reads as such. Women are still suffering under the same conditions that instigated feminism in the 1960s, but to examine the issues publicly has lost favor, especially in the art world." Artist in conversation with author via e-mail, August 28, 2002.

14. Kristine Stiles and Peter Sela, editors, *Theories and Documents of Contemporary Art: A Sourcebook of Artists' Writing* (Berkeley and Los Angeles, California: University of California Press, Ltd., 1996), p. 114.

15. Jeremy Gilbert-Rolfe, *Beauty and the Contemporary Sublime* (New York: Allworth Press, 1999), p. 146.

16. "The line of people is taken from the diagrams of slave ship loading practices. The immediate visual impact of the pieces is kind of a one liner. All these lives going down the drain. There were a lot of people who died during the Middle passage. The sink is a reference to water, the ocean." Artist in conversation with author via e-mail, August 21, 2002.

17. Deborah Menaker Rothschild interview with David Hammons in exhibition catalogue *Yardbird Suite* (Williamstown, Massachusetts: Williams College, 1994), p. 52.

18. Dana Friis-Hansen, Gail B. Sanders, and Erica M. Shamaly, *22 to Watch: New Art in Austin* (Austin, Texas: Austin Museum of Art, 2002), p. 34.

19. Pruitt's taste in hip-hop is diverse and he tends to like "anyone who is lyrically proficient." Also, he points out that the major changes in hip-hop have much to do with the social and political climate. "The MC's that I heard when I was younger were brought up in the early seventies and eighties. MC's from my generation and after who were raised during the Reagan era politics are making a lot of the music heard now on radio and television. One of the unforeseen effects of integration was assimilation and a loss of community. Especially in my generation. We have completely internalized the dominant values of this society and espouse them on the mic. That is why misogyny and violence are so rampant now. Rap music and hip-hop now reflect this dominant structure, instead of remaining a subversive subculture." Artist in conversation with author via e-mail, August 21, 2002.

20. "*2 step* begins with the artist standing in the center of a wooden dance floor (The Cabaret in Bandera, Texas); playing in the background is *I'm just an old chunk of coal* by Billy Jo Shaver and sung by John Anderson. A woman wearing jeans and a black t-shirt enters the frame and knocks the straw cowboy hat off of the artist's head and then departs the scene; she reappears and knocks the hat off once again and then departs; this action repeats throughout the duration of the video." From Chris Sauter's project proposal to DMA, June 2002.

21. Jeffrey Rian, "Past Sense, Present Sense," *Artscribe International* (London) Vol. 73 (January/February 1989), p. 60.

22. In 1993, a group of artists and musicians in Denton formed the Good/Bad Collective for the purposes of experimenting, collaborating, and crossing disciplines. On his experiences with Good/Bad, Thompson said, "G/B was a great environment and think tank if you knew how to interpret the feedback. Members tended to bring

their specialization to the group for others to feed from. But you have to be careful, not matter who your "circle" is, so that work does not become "insider" or cliquish. G/B was an accelerator and an incubator, but to make use of the potential you had to have vision beyond G/B while enjoying G/B at the same time." Artist in conversation with author via e-mail, August 2002 (Good/Bad disbanded when a group of artists tried to relocate the group to Brooklyn).

23. William D. Judson, *Points of Departure: Origins in Video*, exhibition catalogue (New York: Independent Curators Incorporated and Pittsburgh, Pennsylvania: The Carnegie Museum of Art, 1991), p. 16.

24. Hubert L. Dreyfus and Patricia Allen Dreyfus, trans., *Sense and Non-Sense*, (Chicago: Northwestern Press, 1964), p. xvi.

25. Brad Tucker, PS1 website, http://www.ps1.org/cut/snminds/tucker.html.

26. "I tend to make 'signs' based upon the way they look, not the way they 'read'. That is why you will see a Brad Tucker 'sign' piece that says something as inane as 'Fine' or 'Salt' or 'Plum.' I have just pushed letter shapes around to create these words. Also, I want an installation of signs to function phonetically, so that when read in combination, the words will introduce the possibility of narrative utterance in the viewer (i.e., Joes of Boys)." Artist in conversation with the author via e-mail, August 20, 2002.

27. Barry Schwabsky, *The Widening Circle: Consequences of Modernism in Contemporary Art* (Cambridge, England: Cambridge University Press, 1997), p. 33.

28. Ibid., p. 52.

29. *Phenomenology of Perception*, p. xii.

Augusto Di Stefano

I am working toward
an image. The components of
my work result from an

interest in incident and transition—the desire to find a location for examining an encounter. By being deliberate and methodical, and by incorporating a performative aspect to the procedure, I am attempting to leave just enough room for a hermetic, if not abbreviated, narrative.

Augusto Di Stefano
Born 1966, New York City
Lives and works in San Antonio

Augusto Di Stefano earned his B.F.A. at the University of North Texas and his M.F.A. at the University of Texas at San Antonio. He has been given solo exhibitions at Patricia Faure Gallery, Santa Monica, CA, and Finesilver Gallery, San Antonio (2002). Other exhibitions include *Affected, Relapse* at the Project Room, San Antonio, and *Augusto Di Stefano* at UTSA Satellite Space, Blue Star Arts Complex, San Antonio (1999). Group exhibitions across the state include *Not Your Father's South Texas* at the UTSA Gallery, San Antonio, and at Purple Orchid, Dallas; *Biblio-Iotech* at Inman Gallery, Houston; *Texas Dialogues, Parallels: Dallas–San Antonio* at Blue Star Art Space, San Antonio (2001); and *Polyglot* at UTSA Satellite Space, Blue Star Arts Complex (1998).

23

Untitled, 2002
Oil on canvas
Courtesy of the artist

Untitled, 2002
Oil on canvas
Courtesy of the artist

Untitled, 2002
Oil, acrylic, and molding
paste on canvas
Collection of Peter and
Julianna Hawn Holt

Untitled, 2002
Oil on canvas
Collection of Peter and
Julianna Hawn Holt

Working Title, 2002
Oil on canvas
Collection of Jeff and Nancy Moorman

Adrian Esparza

Despues

An evaluation of the sublime locates the point of descent when experience creates an exaggerated flatland of equality. Particles settle upon this plane as remnants of **transcendence...** a transcendence manifested through an acceptance of circumstance.

The object is integrated into an atmosphere that mimics the corkscrew of space and time. The process reveals the object the way a swim past the repetition and fragmentation of the ocean reveals the shore.

My work is renewed within this landscape, where distant memories offer the white light of morning in the midst of fresh dreams and reflections of exiting the sea.

Adrian Esparza
Born 1970, El Paso, Texas
Lives and works in El Paso

Adrian Esparza studied at Yale University Summer School of Music and Art, the University of Texas at El Paso, and the California Institute of the Arts. Selected exhibitions include *Toy Show* (2000), *Blinded by the Light* (1998), and *Interstate* (1997), all at the California Institute of the Arts, Valencia; and *Objects Taken Out of Context* (1996), at the Bridge Center for Contemporary Art, El Paso.

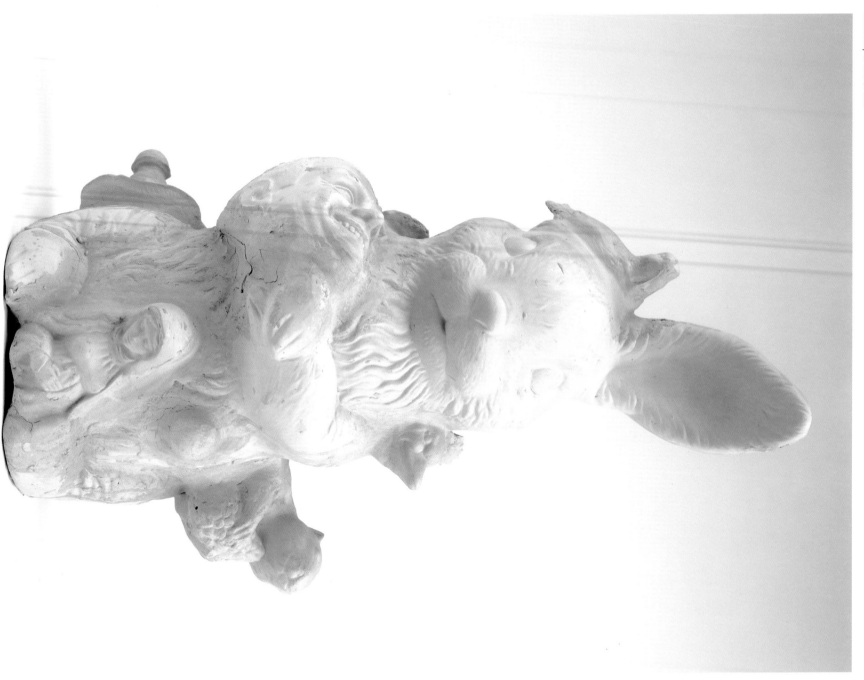

Come and See, 2002
Ceramic
Courtesy of the artist

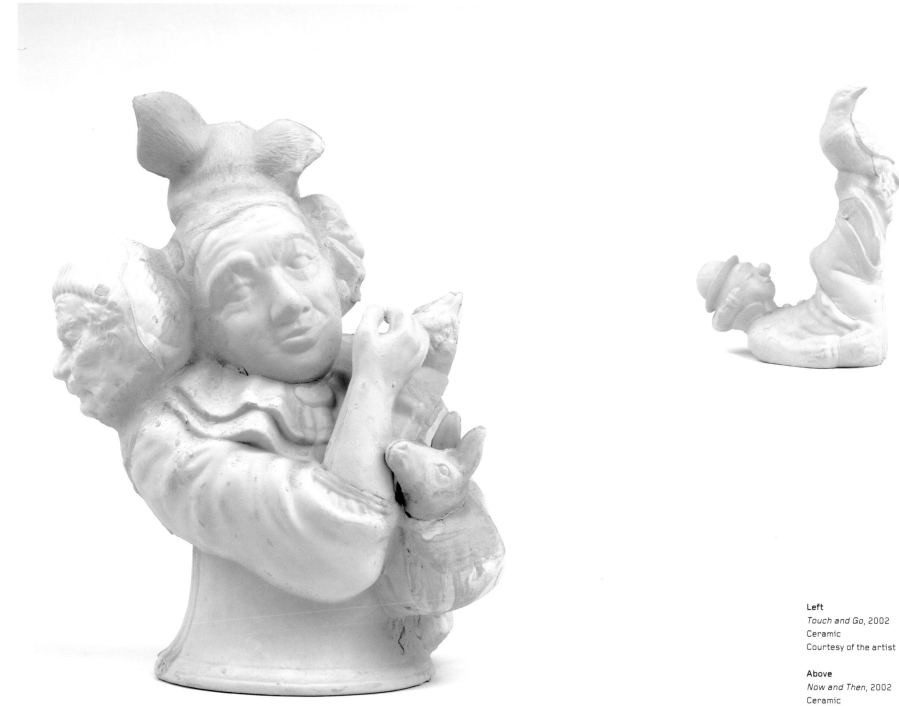

Left
Touch and Go, 2002
Ceramic
Courtesy of the artist

Above
Now and Then, 2002
Ceramic
Courtesy of the artist

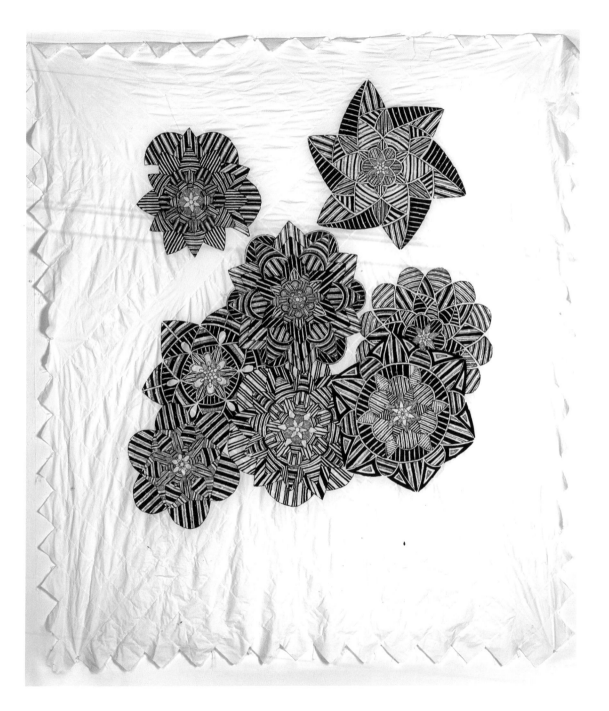

Left
On and On, 2002
Textile paint on pillowcases
Courtesy of the artist

Opposite page
Solids and Liquids, 2002
Textile paint on full-size sheet
Courtesy of the artist

Here and There, 2002
Serape (Mexican blanket),
plywood, and nails
Courtesy of the artist

Joey Fauerso

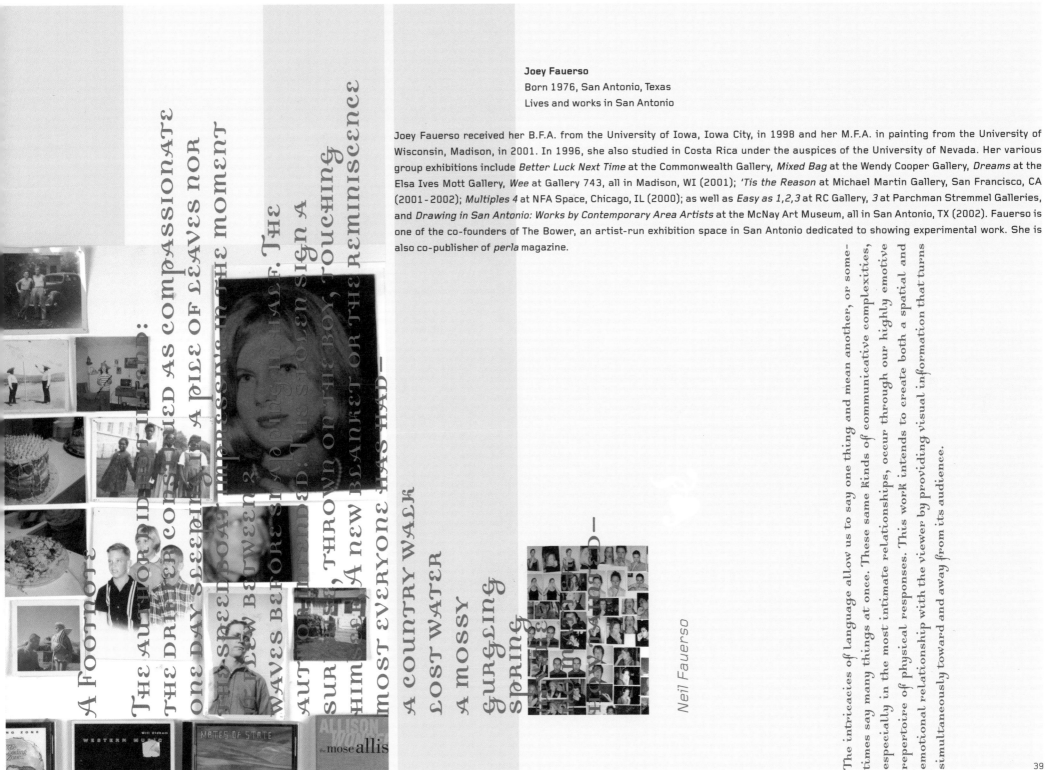

Joey Fauerso
Born 1976, San Antonio, Texas
Lives and works in San Antonio

Joey Fauerso received her B.F.A. from the University of Iowa, Iowa City, in 1998 and her M.F.A. in painting from the University of Wisconsin, Madison, in 2001. In 1996, she also studied in Costa Rica under the auspices of the University of Nevada. Her various group exhibitions include *Better Luck Next Time* at the Commonwealth Gallery, *Mixed Bag* at the Wendy Cooper Gallery, *Dreams* at the Elsa Ives Mott Gallery, *Wee* at Gallery 743, all in Madison, WI (2001); *'Tis the Reason* at Michael Martin Gallery, San Francisco, CA (2001-2002); *Multiples 4* at NFA Space, Chicago, IL (2000); as well as *Easy as 1,2,3* at RC Gallery, *3* at Parchman Stremmel Galleries, and *Drawing in San Antonio: Works by Contemporary Area Artists* at the McNay Art Museum, all in San Antonio, TX (2002). Fauerso is one of the co-founders of The Bower, an artist-run exhibition space in San Antonio dedicated to showing experimental work. She is also co-publisher of *perla* magazine.

Neil Fauerso

The intricacies of language allow us to say one thing and mean another, or sometimes say many things at once. These same kinds of communicative complexities, especially in the most intimate relationships, occur through our highly emotive repertoire of physical responses. This work intends to create both a spatial and emotional relationship with the viewer by providing visual information that turns simultaneously toward and away from its audience.

39

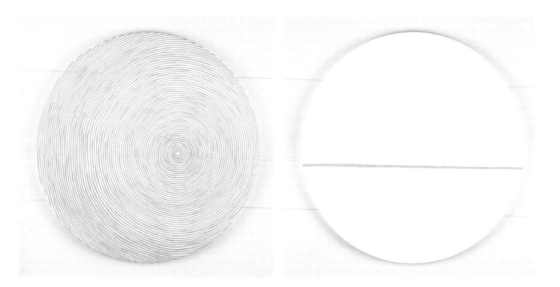

Above
Flipover, 2002
Oil on panel
Courtesy of the artist

Right
enter here, 2002
Oil on panel
Courtesy of the artist

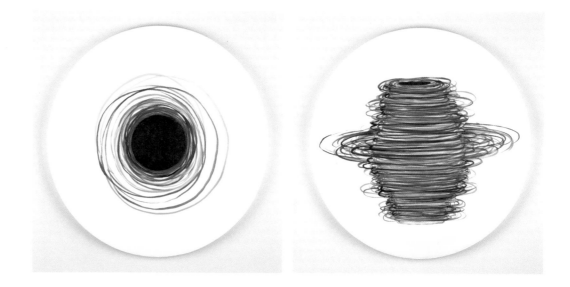

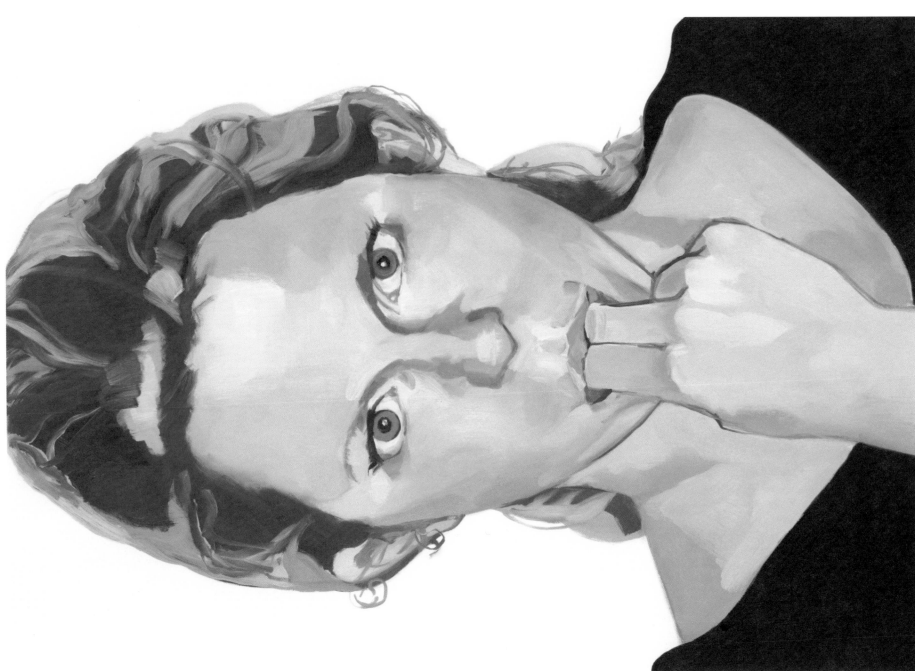

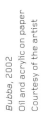

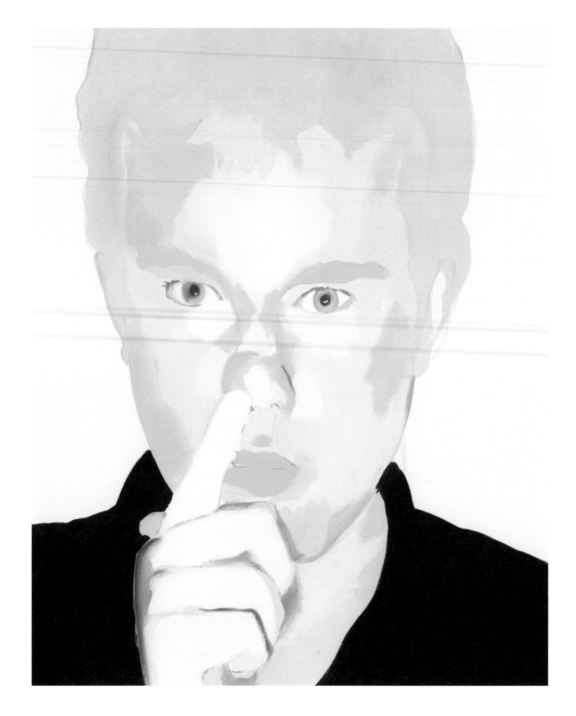

Above
Bubba, 2002
Oil and acrylic on paper
Courtesy of the artist

Right
Neil, 2002
Oil and acrylic on paper
Progressive Corporation,
Cleveland, OH

Opposite page, from left
Neil, 2002
Oil and acrylic on paper
Courtesy of the artist

Michael, 2002
Oil and acrylic on paper
Courtesy of the artist

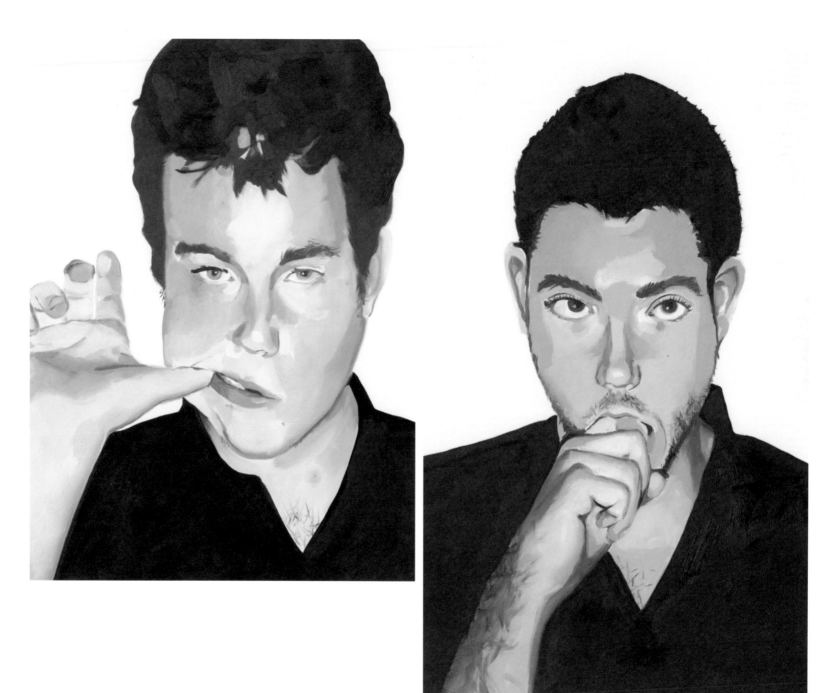

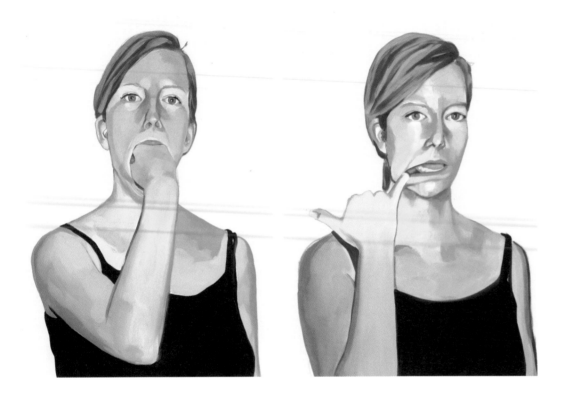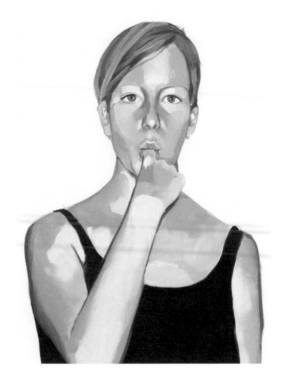

pleaseandthankyou (3 works), 2002
Each oil and acrylic on paper
Collection of Linda Pace

Robyn O'Neil

While I was once dedicated

Robyn O'Neil
Born 1977, Omaha, Nebraska
Lives and works in Houston

Robyn O'Neil completed her B.F.A. at Texas A&M University at Commerce in 2000 and studied for one year at the University of Illinois at Chicago, in 2001. In 1997 she was awarded a fellowship to study British art and architecture at King's College, London. In the fall of 2003, she will participate in the ArtPace International Artist-in-Residence Program, San Antonio. O'Neil's exhibits include *These are Pictures of Boats and Dinosaurs* at Angstrom Gallery, Dallas; *Pin-up* at Bodybuilder and Sportsman Gallery, Chicago (2001); *small abstract paintings and sculpture* at Eugene Binder, New York City; *drawn* at Barry Whistler Gallery, Dallas; *Hi Jinx* at the Arlington Museum of Art, Arlington; *Don't Trust Its Softness* at the University of Texas at Dallas, Richardson (1999); and *Sofa Not Included* at Gallery: Untitled, Dallas (1998).

to making large, colorful, almost entirely abstract paintings, I now critique this approach. I simply make pencil drawings. I believe realistic rendering is a necessary step to move us away from the pretense of flashy color, seductive installation, and reliance on electronic media. What I propose every time I draw a picture is to return to a definition of art as "picture making."

Until recently, the primary subject of my drawings has been middle-aged men. They wear casual attire to suggest their relaxed personas. They are shown running, boating, swimming, and skiing. The subtleties in the way the men walk, shake hands, and carry themselves—with awkwardness, seriousness, horror, and sometimes humor—illustrate the fantastic display of the human condition in even the most mundane situations.

I also have drawn the men's boats. These boats are a lot like the men. I have chosen to display logical, everyday situations in plausible, simply illustrative drawings. They are nondramatic. They are not fantastic. The situations require no subtext. They are pictures of boats.

Fully aware that they don't seem like "advanced" or "sophisticated" enough subject matter, I now draw dinosaurs. They are highly detailed portraits. The drawings are sad depictions of huge beasts that were lucky enough never to have met a human. I think I shall make them for quite some time.

Although the dinosaurs are my main interest, I continue to draw middle-aged men. The men encounter all sorts of problems in their environment, but they keep trying to have a good time. They throw balls. I still draw their boats. Sometimes they crash.

47

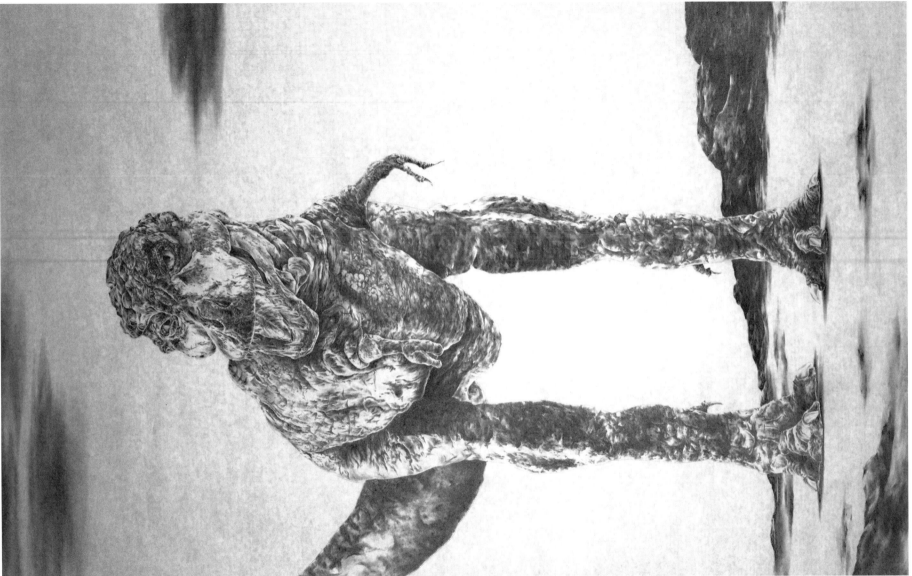

Tyrannosaurus, 2002
Pencil on paper
Courtesy of the artist
and Angstrom Gallery

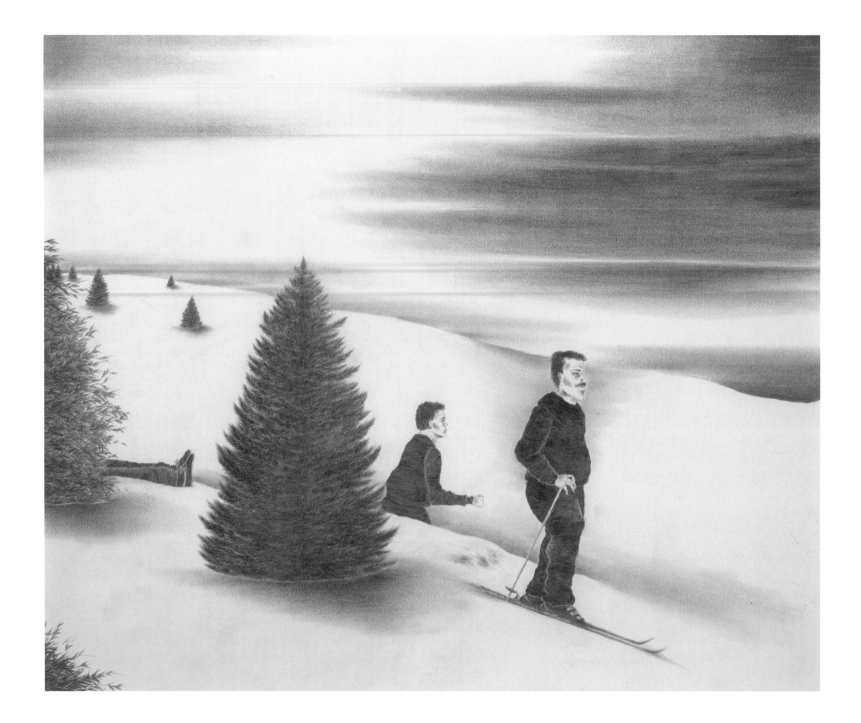

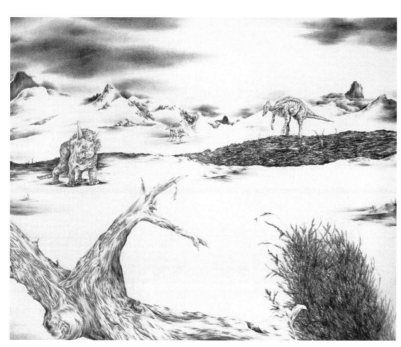

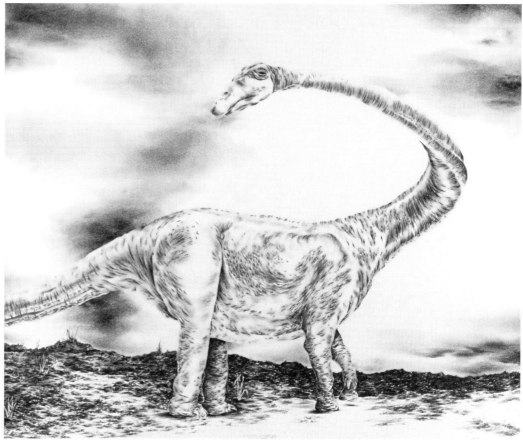

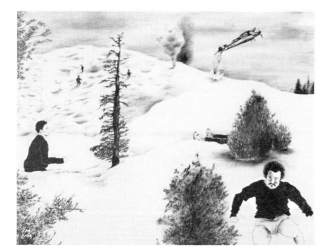

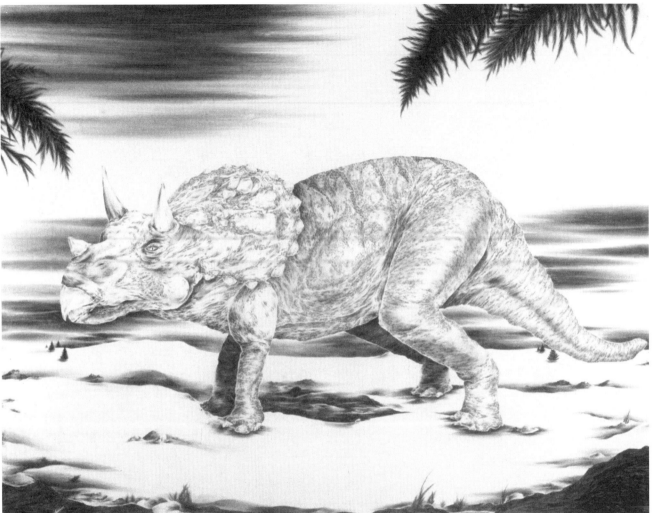

Clockwise from left
Triceratops, 2001
Pencil on paper
Collection of Mark Babcock

Brachiosauras, 2001
Pencil on paper
Collection of John Reoch

Boats, 2001
Pencil on paper
Collection of Claire Dewar

Photographs courtesy of
Angstrom Gallery

Robert Pruitt

Robert Pruitt
Born 1975, Houston, Texas
Lives and works in Austin

Robert Pruitt received his B.F.A. from Texas Southern University in 2000 and is working toward an M.F.A. at the University of Texas at Austin. His work has been shown in a variety of exhibitions across Texas, such as *3 Centuries of African American Art* at the African American Museum, Dallas; *22 To Watch: New Art in Austin* at the Austin Museum of Art (2002); *Umfrumnat Tre* at the New Gallery, the University of Texas at Austin (2001); *Our New Day Begun: African American Artists Entering the Millennium* at the LBJ Library and Museum, Austin (2000); *Strange Fruit* at Diverse Works Subspace Gallery, Houston (1999); and *Preventions* at Project Row Houses, Houston (1996). Pruitt was Resident Artist at the Skowhegan School of Painting and Sculpture, Maine, 2002.

The interconnectedness of blacks, Africa, and the very slippery slope of history, is the recurrent theme in the things I create. I collect objects from places I live or once lived, using them as found art materials and as artifacts stained with memory and meaning. There is an existentialism to whatever is created or done by African Americans within a racist society. To say, see, do, be, or use something outside of our imposed limits could at anytime result in physical, mental, or spiritual damage. I take objects and ideas out of their historical contexts and connect them in new ways. I believe this regrouping shows how we are greater than our present station suggests. The constant public humiliations of African Americans are a reminder of our humanity. I want to chronicle and even alter history to reflect this humanity, and give an Olympian status to our ancestors. I am searching for a history that reflects our present diversity and creates a comfortable context in which we can exist as whole human beings.

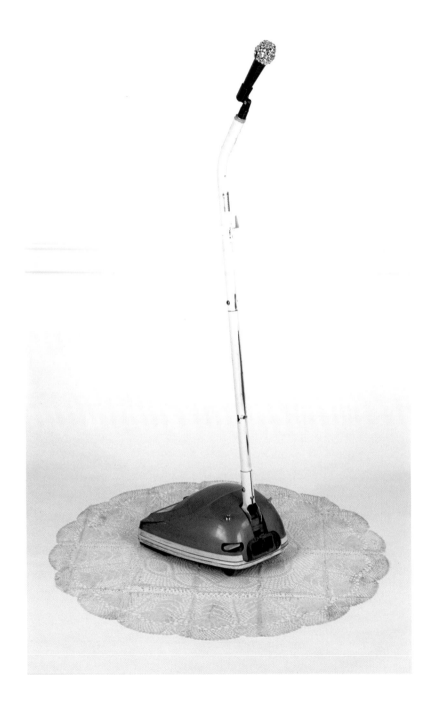

me and this mic is like yin and yang, 2002
Microphone, vacuum cleaner
Courtesy of the artist

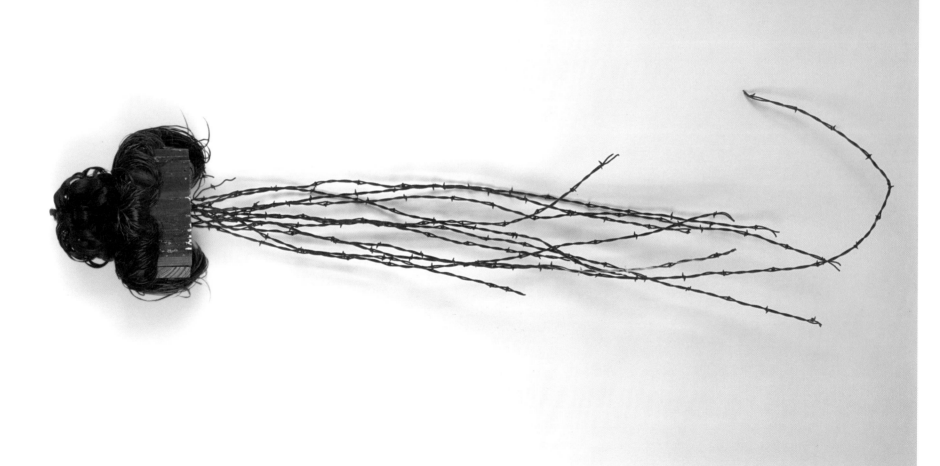

babee yo roots R showin, 2002
Wood, barbed wire, hair weave
Courtesy of the artist

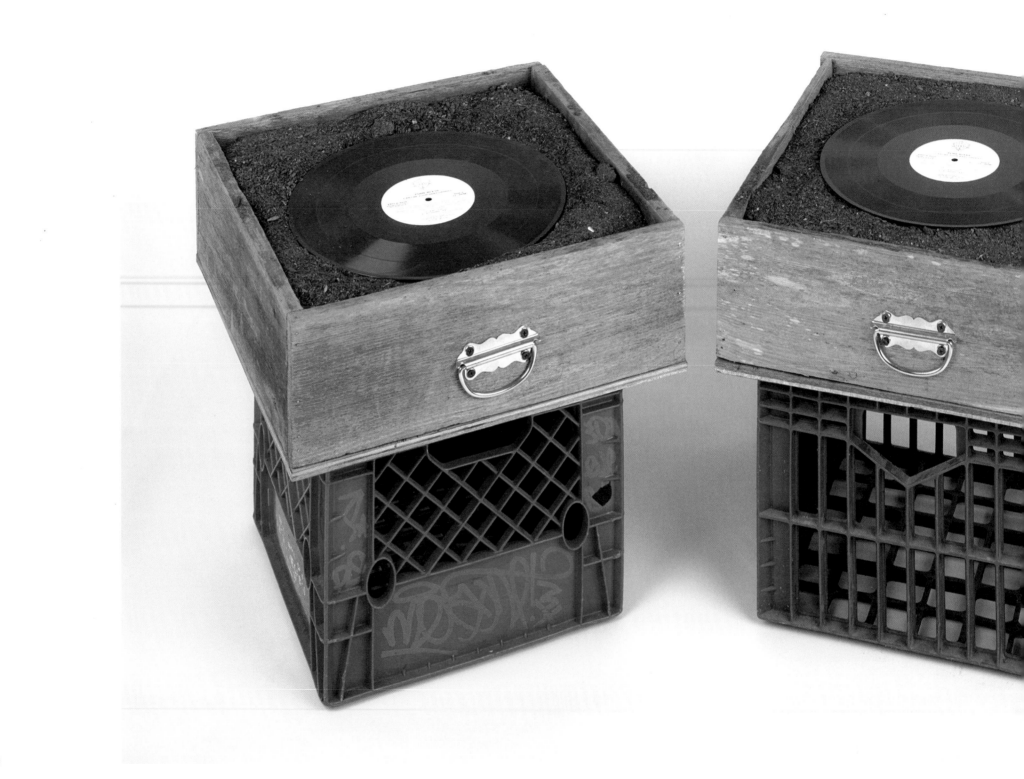

THA Ten Commandments, 2002
Wood, dirt, vinyl, milk crates
Courtesy of the artist

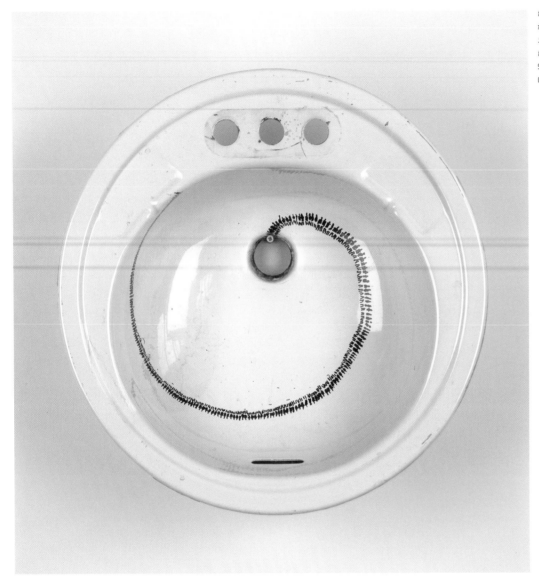

the devil planted fear
inside the blak babies,
50 cent sodas in the hood
they go crazy, 2002
Sink and marker
Courtesy of the artist

Juan Miguel Ramos

MY PRINTS AND VIDEOS CONSIST MOSTLY OF FIGURATIVE AND NARRATIVE IMAGERY THAT DEALS WITH RELATIONSHIPS BETWEEN PHOTO AND DRAWING, MACHINE AND HAND, MEMORY AND IMAGINATION, PLACE AND IDENTITY. I USU-ALLY PRESENT A GROUP OF IMAGES IN A SUITE, SERIES, OR GRID OF SOME KIND. THE IDEA IS THAT COLLECTIVELY THEY MAKE A BIGGER STATEMENT ABOUT PLACE THAN A TRADITION-AL STAND-ALONE PORTRAIT.

Juan Miguel Ramos
Born 1971, San Antonio, Texas
Lives and works in San Antonio

Juan Miguel Ramos earned both his B.F.A. and M.F.A., in 1995 and 2001, respectively, from the University of Texas at San Antonio. He participated in the ArtPace International Artist-in-Residence Program, San Antonio (*New Works: 02.3*). Ramos' exhibitions include *Red Dot* at Blue Star Art Space, San Antonio; *Building Blocks* at the Dallas Center for Contemporary Art, Dallas; *Traces of Culture* at Mexic-Arte Museum, Austin; *Stolen~properties* at Sala Diaz, San Antonio (2001); and *Telstar 2000* at the UTSA Satellite Space, San Antonio (2000). He is a percussionist with *Sexto Sol*.

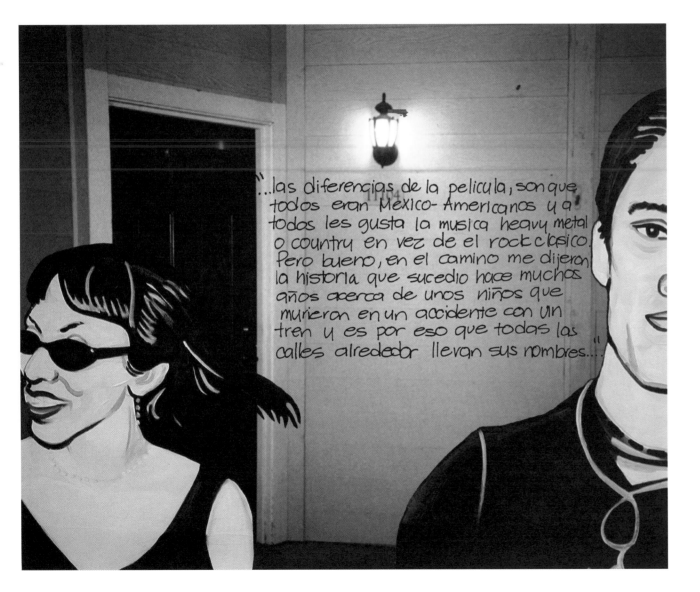

Left
Ghost Story #4, 2001
One of ten digital prints
Courtesy of the artist

Opposite page
Ghost Story #5, 2001
One of ten digital prints
Courtesy of the artist

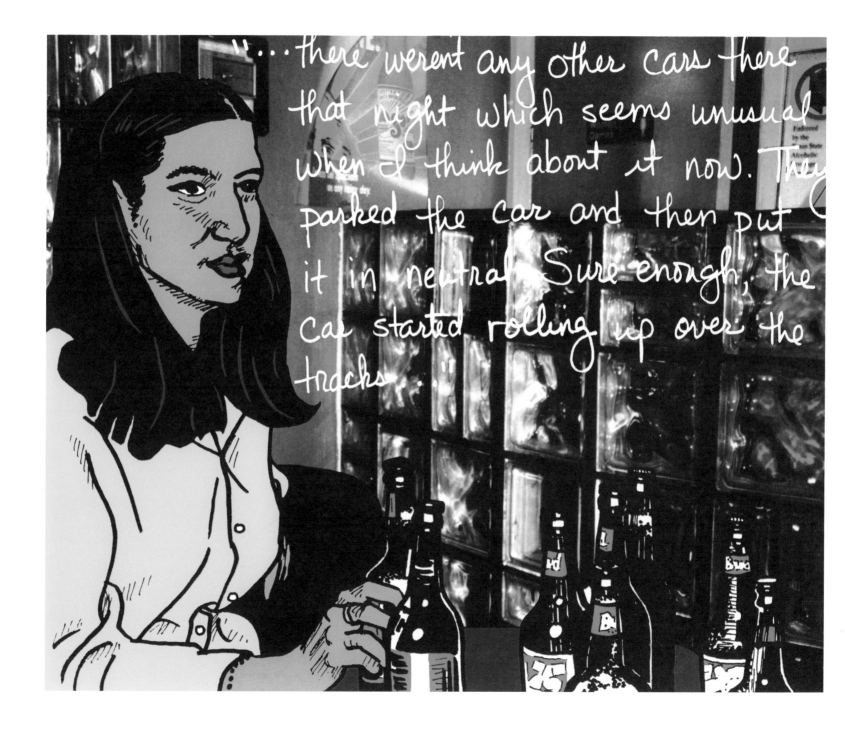

I like Lena's new truck. I always make her drive when we go out now because we can all fit in it. I've known her a long time, which is nice because a lot of our friends from highschool went off somewhere for college, or if they went to college here, they moved someplace else for a job. Lena went to UTSA and then got a job at USAA.

I miss hanging out with Tonantzin. I'm happy for her though. She seems to be happy. Sometimes I feel bad that she pays for all the long distance but she can afford it. She told me she's financing a CD for her prima Julie's new band. Lena's playing bass and Sandra's playing drums. I thought it was a weird idea because all I've ever heard them play is cover songs. How're they going to put out a CD of Ozzy, Judas Priest and Metallica songs? By the way they're playing at Tacoland on Thursday.

Julie has a poster of Randy Rhoads that she decorated to look like he's a catholic saint. "San Randy, patron saint of southside heavy metal lead guitarists."

Secret City, 1999 - 2002
Six of fifteen photocopies on archival paper
Courtesy of the artist

Robert has a theory that the sound of the accordion enters the ears and causes a reaction in the brain which stimulates a need to drink beer. I could just imagine a bunch of German folk sitting at bench tables in a beer garden holding up their big steins in agreement. Based on how drunk I used to get at Steve Jordan shows, I'm tempted to buy into that idea.

Tonantzin's such a big star these days. It amazes me sometimes. I have vivid memories of the two of us checking out my padrino's Batman comics inside the closet of his bedroom while he and our parents were partying in his apartment...

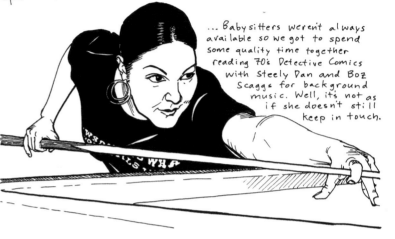

... Babysitters weren't always available so we got to spend some quality time together reading 70's Detective Comics with Steely Dan and Boz Scaggs for background music. Well, it's not as if she doesn't still keep in touch.

Even though our job was to push freight for Target, Roger always wore cleaned and ironed clothes to work. Even his low-top black suede Nikes were cleaned. He was from L.A. and I could tell that he was different from us Tejanos in more ways than the way he talked sometimes...

... Once he was joking around holding out a full can of beer and spilling some on the ground. Something about "dead homies." And yeah, it was just a tall boy of Lone Star but I still felt compelled to let him know that intentionally spilling beer wasn't looked upon very agreeably here in Texas.

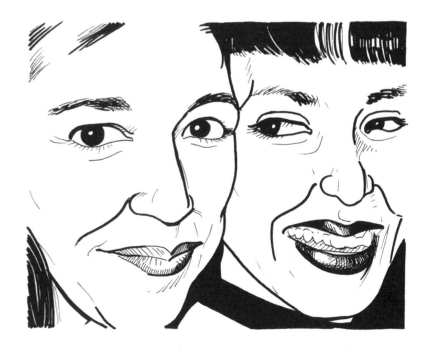

Mirror Maps, 2001
Four iris prints
Courtesy of the artist

Sofia's Map, 2001
Four of seven digital prints
Courtesy of the artist

Irene Roderick

Irene Roderick
Born 1950, San Diego, California
Lives and works in Austin

After studying communications, advertising, and mathematics at the University of Texas at Austin and the University of North Carolina at Chapel Hill in the 1960s, '70s, and '80s, Irene Roderick returned to UT-Austin to study art, receiving a B.F.A. in 1999. She earned her M.F.A. at the California Institute of the Arts in 2001. Roderick has had solo and group exhibitions across the country, including *White* at the California Institute of the Arts, Valencia (2001); *22 to Watch* at the Austin Museum of Art, Austin; *Reactions* at Exit Art, New York City (2002); *Have a Cool Summer: Keep in Touch* at Track 16 Gallery, Bergamot Station Arts Center, Santa Monica, CA; *Chance Meetings* at the California Institute of the Arts (2001); *Sacred Spaces* at the Main Gallery, California Institute of the Arts; *Reexamining Pictures* at the Stevenson Blanche Devereaux Gallery, Los Angeles; *Interior/Exterior* at Mint Gallery, California Institute of the Arts (2000); and *Fast Food* at the National Exhibitions, Edison Community College, Piqua, Ohio.

My recent white-on-white paintings are based on architectural façades and the connection between exterior appearances and interior space. I am attracted to the symbiotic relationship between this two-dimensional "face," the three-dimensional space it covers, and how one informs the other. I am using the façade as a metaphor while building pictures that play with questions of appearance and identity—mirror image versus dimensionality of the body, for example, and persona versus personality.

In this series there are references to the walls of the white cube, modernist painting concerns (surface, monochrome, horizontality, masculinity), and spatial disjunctions. These paintings also refer to a discussion of the relationship between beauty, abjection, and femininity, and the "problem with painting"—is it dead? still breathing? somewhere in between, like a zombie? As Douglas Fogle's catalogue essay for *Painting at the Edge of the World* makes clear, the debate in the art world is still raging.

Façade Series: Motorcycle I, 2002
Latex primer on architectural film
Courtesy of the artist

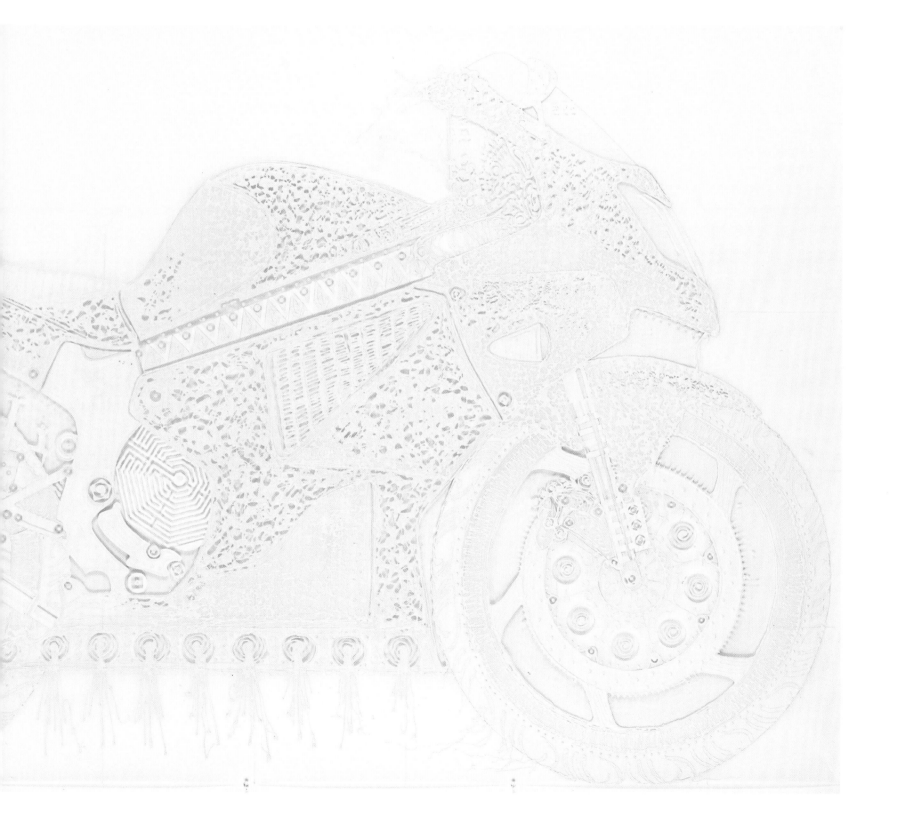

Above
Façade Series: Double Arches, 2001
Latex primer on architectural film
Courtesy of the artist

Opposite page
Façade Series: Pink, 2002
Latex primer on architectural film
Courtesy of the artist

Façade Series: Tomb, 2002
Latex primer on architectural film
Courtesy of the artist

76

Chris Sauter

Born 1971, San Antonio, Texas

Lives and works in San Antonio

In 1993 Chris Sauter earned his B.F.A. from San Antonio's Incarnate Word College (now the University of the Incarnate Word). He completed his M.F.A. at the University of Texas at San Antonio in 1996. In 1999, Sauter was a participant in the ArtPace International Artist-in-Residence Program, San Antonio (*New Work: 99.3*). Sauter's exhibitions include *I'm Just an Old Lump of Coal* at Three Walls, San Antonio; *10X3* at the San Antonio Museum of Art, San Antonio (2002); *Light Industry* at Cactus Bra Gallery, San Antonio (2001); *Charles LaBelle, Chris Sauter* at Sala Diaz, San Antonio; *Out of the Ordinary*, New Work From Texas at the Contemporary Arts Museum, Houston (2000); *Objects: Blurring the Line Between Fine and Decorative Art* at the UTSA Satellite Space, San Antonio; *Generation Z* at P.S. 1 Contemporary Art Center, New York City; *Phenotypology* at Hallwalls Contemporary Arts Center, Buffalo, NY (1999), *Space: Architecture + Installation* at the Arlington Museum of Art, Arlington (1997); *Double Trouble: Mirrors, Pairs, Twins, Lovers* at Blue Star Art Space, San Antonio (1996).

My exploration of bull riding focuses on the premise that the cowboy (bull rider) is a cultural construct and the bull is a purely biological entity. In bull riding, the bull and rider share equal importance as the performance of each is judged. The goal is to achieve a perfect ride within the allotted time of eight seconds. During that perfect ride, the cowboy and bull perform in unison, with neither dominating the other. This interaction merges the rider and the bull: The result is a Minotaur of sorts, which lives for only a short time because the cowboy is bucked off of the bull, the bull submits to the rider, or the eight-second time limit is reached. The Minotaur is created and destroyed with each new ride.

The interaction between the bull and rider is analogous to the human process of navigating between genetic predispositions and cultural pressures. *Identity* is merely the term given to this process. To ride the bull is to engage the Minotaur. To engage the Minotaur is to consciously participate in the process.

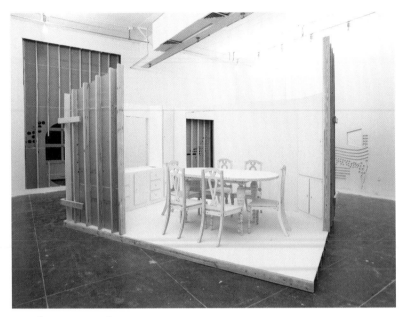

Graft (installation view), 1999
Mixed media installation
Commissioned by ArtPace,
A Foundation for Contemporary Art,
San Antonio

Below
Sketches for *Engaging
the Minotaur*
Courtesy of the artist

Opposite page
Signs from the
Dining Room Arena
Courtesy of the artist

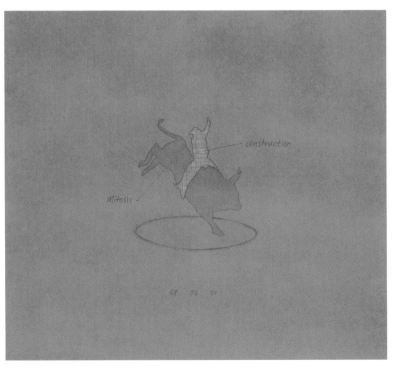

Gender Brands
Forged steel
Courtesy of the artist

CONSTRUCTION

BIOGRAPHY

C O M P A N Y

Colon
FAMILY
RESTAURANT

FAMILY OWNED • FAMILY OPERATED

La Grange
NURSERY
Plants, Fruit Trees, Vegies

Q U A L I T Y

MITOSIS

s e e d s

NATIONAL
ENGINEERING
CONCEPTS

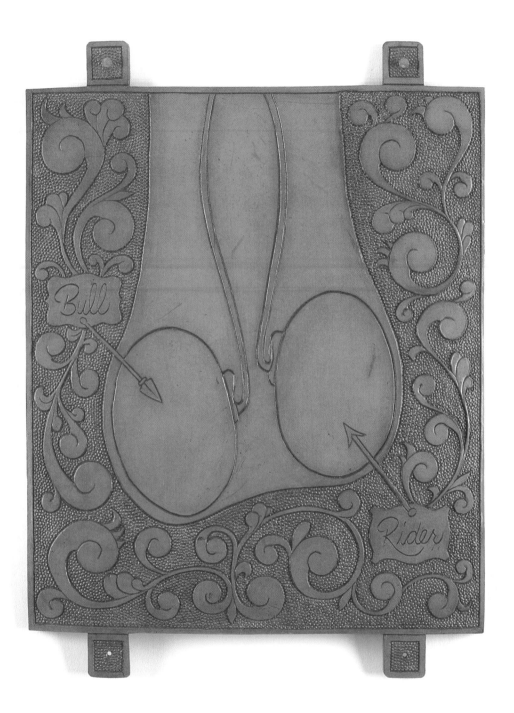

Left and opposite page
Minotaur testicles
Minotaur ovaries
Tooled leather, tacks
Courtesy of the artist

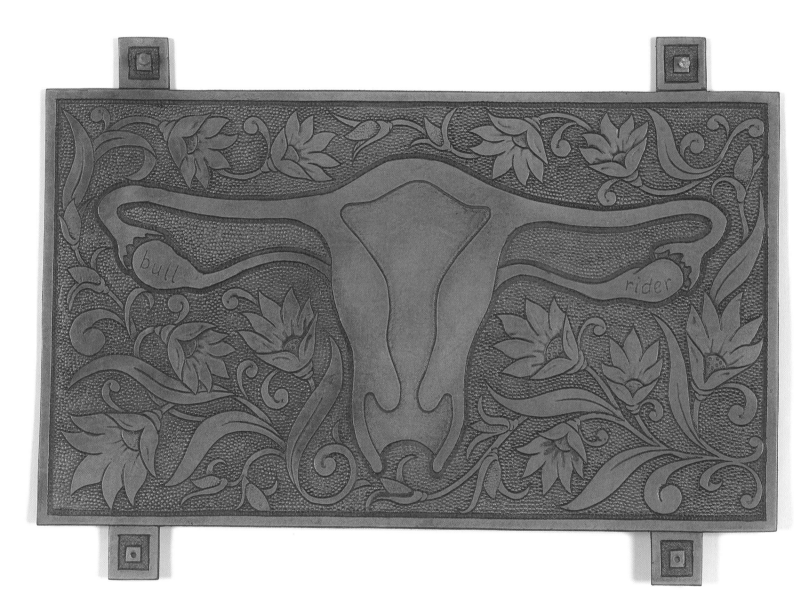

Above
Hat
Wooden hat rack, straw
cowboy hat (Resistol),
tooled leather hat band, bucket
Courtesy of the artist

Right
Mom/Dad, Bull/Cowboy
Framed photograph
Courtesy of the artist

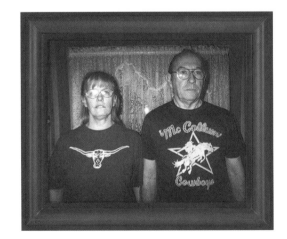

Brent Steen
Born 1974, Dallas, Texas
Lives and works in Houston

Brent Steen received his B.F.A. from the University of North Texas in 1998 and attended the University of Houston for his M.F.A., which he completed in 2001. Besides a show at Inman Gallery, Houston (2002), Steen's selected exhibitions in Texas include *The Core Show* at the Glassell School of Art, Museum of Fine Arts, Houston (2002); *Black Air: New Film and Video from Houston* at Aurora Picture Show, Houston (2001); *Out of the Ordinary* at the Contemporary Arts Museum, Houston (2000); and *Hybrid Forms* at the Good/Bad Art Collective (1998).

"Frank Kermode wrote 30 years ago in his wonderful book *The Sense of an Ending* that, 'It is not that we are connoisseurs of chaos, but that we are surrounded by it, and equipped for coexistence with it only by our fictive powers.' To my mind, not to believe in invention, in our fictive powers, to believe that all is traceable, that the rabbit must finally be in the whole waiting is (because it's dead wrong) a certain recipe for the williwaws of disappointment, and a small but needless reproach to mankind's saving capacity to imagine what could be better and, with good hope, to seek it.

—*Richard Ford*"

"I had this old pencil on the dashboard of my car for a long time. Every time I saw it, I felt uncomfortable since its point was so dull and dirty. I always intended to sharpen it and finally couldn't bear it any longer and did sharpen it. I'm not sure, but I think that this has something to do with art.

—*John Baldessari*"

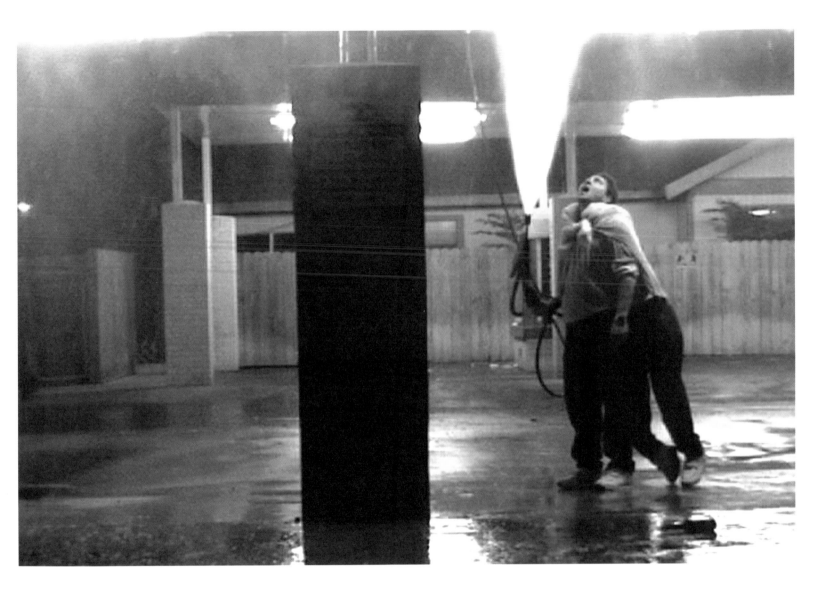

Still from *It's okay...okay, 2001*
Video projection
Courtesy of the artist and Inman Gallery, Houston
Image courtesy of the artist

Still from *It's okay...okay, 2001*
Video projection
Courtesy of the artist and Inman Gallery, Houston
Image courtesy of the artist

Still from *It's okay...okay, 2001*
Video projection
Courtesy of the artist and Inman Gallery, Houston
Image courtesy of the artist

Still from *It's okay...okay, 2001*
Video projection
Courtesy of the artist
Image courtesy of the artist

K.C. can you cry on command?
B.S. yeah, but it's a different kinda cry
K.C. can't let it fully go 'cause you're noticing that you're noticing that you're noticing...
B.S. yeah
K.C. yeah
B.S.
K.C.
B.S.
K.C. what about a regular cry?
B.S.
K.C.
B.S.

What about a regular cry?
(My conversation with
Kurt Cobain) (detail), 2002
Pencil on paper
Private collection, Houston

sailormouth

Baby T About Hard Astern Tricks

03.30.01

?

03.26.01

It is funny how things work sometimes. I was in a rush the other day putting a circuit back together on a bread board when I placed a wire in a wrong place. Or course I tried part of the "Robot Voice" circuit. To my benefit it was the more limiting part of the circuit. Looking through the schematic and description I realized the circuit could really be expanded while remaining simple. Without the "set back" I would not have noticed the real potential of the circuit.

03.21.01

My friend David told me a few months ago about an interview he had seen with Jon Stewart. The interviewer asked Mr. Stewart if it was hard for a comedian to be creative and where she sees art. He said (coming along the lines of), there is no creativity. You have to use reactive material so the audience can understand". Observational Humor. To me that is the problem with a majority of art. It doesn't allow you to dream. It tends to be spoon feeding, or it is the other end of the pendulum, too personal. Art to me should have some mystery. People seem to believe that art is objective. People need to realize it is subjective. Critics and historians can give their opinion based on rules and standards, but it is still their opinion. How you respond to art is the crux. Not all art is about understanding what the artist is "saying". Truly amazing art will transcend rules and standards, even your own. A good comedian can take a topic that people have some familiarity with add his/her own personal anecdote, and make people laugh and possibly reflect on their own experiences. A great comedian is like a good comedian except they use a vaguely known

Address: http://www.sailormouth.org

Back Forward Stop Refresh

Marshall Thompson

Marshall Garth Thompson
Born 1972, Salinas, California
Lives and works in Dallas

Marshall Garth Thompson attended the University of North Texas in Denton, where he received B.F.A.'s in sculpture and metalsmithing/jewelry. Besides appearing in numerous exhibitions at the Good/Bad Art Collective, his work has been shown across the state in exhibitions including *Nip and Tuck* at Gallery_803, Denton (2001); the Texas Fine Art Association Artistic Center traveling exhibition; *Hi Jinx* at the Arlington Museum of Art, Arlington, and the University of Texas at Dallas, Richardson (2000); *Fire Sale 2000* at Angstrom Gallery, Dallas; *Eye 35* at Blue Star Art Space, San Antonio; *Welcome to Important Town* at the Conduit Annex, Dallas (1998); and *Very Fake, But Real* at Diverse Works, Houston (1997).

I relate my art to magic, in that it is a means to thrill and entertain. Like a good magician, I do not limit myself to one format or medium. Magicians who do card tricks can be amazing, but they are even more so if they add rings, scarves, coins, and other tricks to the mix. I strive to be well versed in materials and techniques so I can expand the possibilities of what I make. Doug Henning once said, "The only thing a magician ever really does is to ask one question. What's real and what's illusion?"

I create tactile representations of intangible thoughts and daydreams. I dream of nonsensical connections, and I find a logical rationale for making them material. The nautical theme in my work gives me freedom to roam, has a wealth of possibilities for new pieces, and relates to a subject that a majority of people has, in one way or another, encountered or experienced—waves, lighthouses, pirates, sailors, maps, boats, ships, treasures, and so much more. I provide more questions than answers in my work, leaving interpretations open to the audience. My own motivations and focus are not the point or meaning of the work. Viewers do not need to have any particular background to view it, but the more experienced or knowledgeable they are, the better they might pick up on its subtleties. What I make is like a video game with secret rooms that only some might enter but access to which is not necessary to play the game.

Left, from top
Sea Life, S1, 2002
Wood, acrylic, and acrylic paint
Courtesy of the artist and Angstrom Gallery

Sea Life, S2, 2002
Wood, acrylic, and acrylic paint
Courtesy of the artist and Angstrom Gallery

Opposite page, from left
Porthole Melt, 2002
MDF, acrylic, and acrylic paint
Courtesy of the artist and Angstrom Gallery

Porthole Sag, 2002
MDF, acrylic, and acrylic paint
Courtesy of the artist and Angstrom Gallery

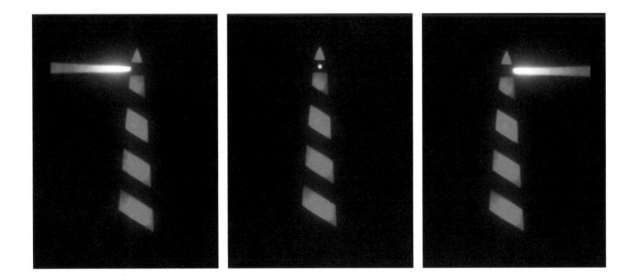

Untitled (lighthouse), 2001
(shown with light on and off)
Birch, acrylic, electronics, and
laminated paper
Courtesy of the artist and Angstrom Gallery

Pantswave, 2000
Denim
Courtesy of the artist and Angstrom Gallery

Brad Tucker

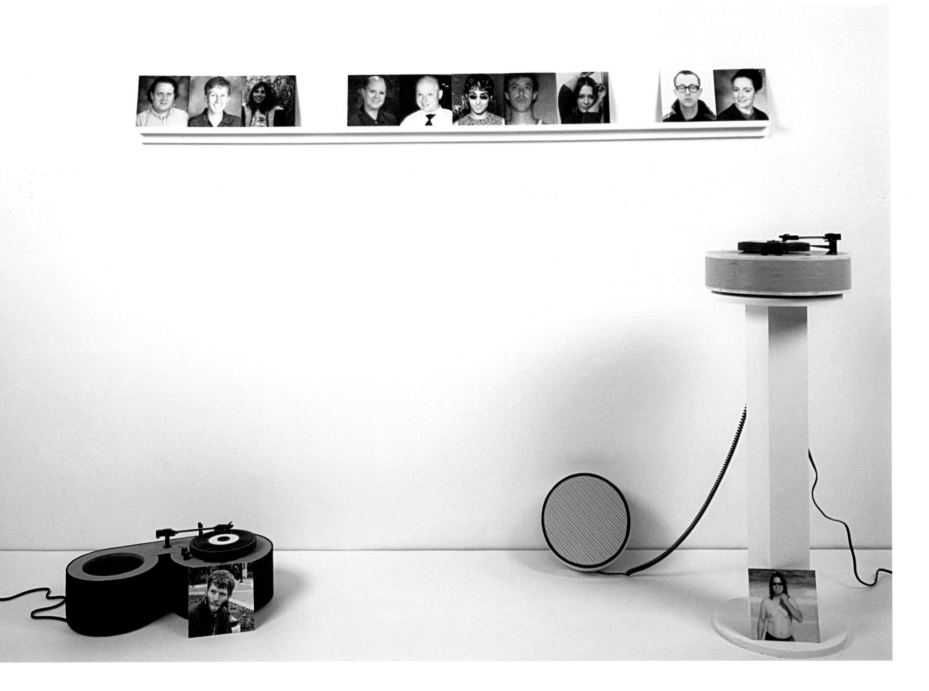

Brad Tucker
Born 1965, West Covina, California
Lives and works in Houston

Brad Tucker completed his B.F.A. at the University of North Texas in 1991. Selected recent national and international exhibitions include *Flip/Flop* at Lombard-Freid Fine Arts, New York City; *The Verge* at Plains Art Museum, Fargo, ND; *Brad Tucker* at Ray Gun Gallery, Valencia, Spain (2002); *Drum Solos* at Inman Gallery, Houston; *Core Exhibition 2001* at Glassell School of Art, Museum of Fine Arts, Houston (2001); *Brad Tucker* at Angstrom Gallery, Dallas; *Some New Minds* at P.S. 1 Contemporary Art Center, New York City; *Stempo* at Homeroom, Munich, Germany; *Francesca Fuchs, Katrina Moorhead, Ludwig Schwartz, Brad Tucker* at Inman Gallery; *Hi Jinx* at the Arlington Museum of Art, Arlington, and University of Texas at Dallas, Richardson (2000); *Fire Sale 2000* at Angstrom Gallery (1999); and *Jeff Elrod, Mark Flood, Brad Tucker* at Angstrom Gallery (1998). In 2002, Tucker was voted Teacher of the Year at the Henry W. Grady Middle School, Houston.

My work

tends to go off in several directions at once. In general, one could say that it is invested in ideas pertaining to painting. But rather than work with illusionistic space, I have chosen to focus on the material, pragmatic aspects of painting. As a result, my work occupies a space somewhere between painting and sculpture. Accepting the color field as a starting point, I have given my attention to the periphery of painting—its support, frame, colored surface, and presence as an object in space. At the same time, the objects I construct tend to veer decidedly away from traditional sculptural concerns. When seen in the round, they reveal a front and back. Some butt up against a wall; others flatten themselves out on the floor.

Recently, I have invited other people to participate in various musical projects for which I produce sound recording and cast original records. With these works, I am not only exploring analogies between artistic and musical production but also finding new ways to invigorate and animate the surfaces of my works.

Opposite page
Singles, 2002
Wood, fabric, turntable parts, speaker,
12 seven-inch acetate records,
2 customized turntables (one with built-in speaker),
one speaker, shelf with 12 record covers featuring
images of the 24 recording artists (one per side)
Courtesy of the artist and Inman Gallery, Houston

Above
Two Lefts, 2002
Cast foam and plastic
Courtesy of Dianne and Mark LaRoe
Photograph courtesy of the artist

Right
Head Phones, 2002
Cast plastic, foam, and fabric
Courtesy of the artist and Lombard-Freid Fine Arts
Photograph courtesy of Lombard-Freid Fine Arts

Clockwise from top
June Bug (whistle), 2002
Wood, paint, and polyester
Courtesy of the artist and Lombard-Freid Fine Arts
Photograph courtesy of the artist

Slythering, 2000
Latex on wood
Anonymous Dallas Collector

Bond, 2001
Plastic and wood
Collection of John Griffith and Angie Paez
Photograph courtesy of the artist

Double Drum Speaker (figure eight), 2001
Latex on wood, fabric, speakers, drum leg
Collection of Gregory Higgins
Photograph courtesy of the artist

Clockwise from above
Lee, 2000
Foam rubber
Courtesy of the artist

Who's Asking, 2001
Acrylic on canvas
Collection of Richard Roberston

Athena, Aphrodite, Hera, 2000
Acrylic, various other fabrics, wood
Courtesy of the artist and
Inman Gallery, Houston

Opposite page
Fine, 2001
Painted wood
Collection of Robert J. Card, M.D.,
and Karol Kreymer

Photographs courtesy of the artist

Emerging Criticism in Texas

No Place Like Home — Jennifer Davy

Three young art critics affiliated with three Texas institutions, each of which is known for advancing ambitiously conceived contemporary art criticism, have been asked to contribute essays to this catalogue which articulate some of the issues now confronting artists of their generation. Jennifer Davy is completing her master's degree in art history under the direction of Frances Colpitt at the University of Texas at San Antonio; she also has curated a number of shows, including *Stolen~properties* at Sala Diaz in San Antonio. Alexander Dumbadze is a doctoral candidate in art history at the University of Texas at Austin, and has written about contemporary art in Texas for *ArtLies*, *Art Papers*, and *New Art Examiner*; he currently lives and works in New York. Having received an M.F.A. at the University of Wisconsin, Madison, Hilary Wilder is currently Core Resident in Critical Studies at Glassell School of Art, Museum of Fine Arts, Houston; she is also co-founder of The Bower, a project space in San Antonio.

Place, as a concept, operates both geographically, as in "a place," and socially, signifying "one's place" as an aspect of identity. Yet in this increasingly nomadic culture a sense of place has become elusive. The emergence of globalism, and the subsequent capitalization of it, is shifting the boundaries of identity and geography, and as a result, place becomes valuable only as abstract nostalgia, or its value is superceded by what Paul Virilio calls the "strategic value of speed's 'noplace.'"[1] The "valuable" pace of contemporary life creates a constantly shifting world, which in turn produces a transitory culture characterized by "urbania" (the global environment), the Internet (the virtual global environment), and the technological capabilities to place oneself in either. The typical urban airport is the quintessential nonplace: Regardless of its location—DFW, LAX, JFK—the airport is essentially the same transitory site where one is suspended between places. Korean artist Do-Ho Suh captures this sensation in his convertible "to-go" piece *Seoul Home/Los Angeles Home/New York Home/Baltimore Home* (1999), a fabricated nylon replica of the artist's apartment that can be packed up and then opened and hung from the ceiling like a tent for "living."

A global society makes place less easily recognizable or definable. The densest population centers in the world have become more similar than distinctive,

Do-Ho Suh, *Seoul Home/Los Angeles Home/New York Home/Baltimore Home*, 1999, silk and metal armatures, 149 x 240 x 240" (overall), The Museum of Contemporary Art, Los Angeles, purchased with funds provided by an Anonymous donor and a gift of the artist

Gregory Crewdson, *Untitled (Boy with Hand in Drain)*, 2001-2002, digital C-print, The Rachofsky Collection and the Dallas Museum of Art: DMA/amfAR Benefit Auction Fund, courtesy of the artist and Luhring Augustine, New York

like genres of places rather than particular places themselves. A modern nomad may physically travel from place to place while always arriving at the same generic cultural "site." In relation to the art world, Kwanju has more in common with Manhattan than Queens does. Place is here neutralized by its generic identity; the result is a sense of being isolated or left out (epitomized by the seemingly alien or artificial environs rendered in artist Gregory Crewdson's photographic tableaux, in which it is difficult to descry a particular place).

Some contemporary artists are attempting to reinterpret and even reinvent a sense of place in response to this growing distance between habitat and inhabitant. The trend of nostalgia-influenced work can be interpreted not as a longing for the past so much as a need to detach from the present—an idea represented by the appropriated images of the German artist Neo Rauch. Informed by life in the German Democratic Republic, these paintings illustrate implausible recreational scenes set in a nowhere place. Rauch renders such uncertain subject matter in a style akin to socialist realism, yielding a generic image of desolate everyday anonymity. This nostalgia for artificial environments means to promote a sense of belonging but instead fosters a sense of being alien in an otherwise familiar context. Whereas the generic place seems to be inclusive, it's not really; our experience of inclusion is in fact, as Michel Foucault puts it, "only an illusion: we think we enter where we are, by the very fact that we enter, excluded."[2]

Artists have long approached the seemingly ordinary and commonplace from a unique perspective, rendering the common as distinct. Yet much contemporary art sees the seemingly ordinary from a perspective that renders the common as unknowable. The ordinary is now interpreted in the same inquisitive and curious manner in which both Jean-Auguste-Dominique Ingres and Eugène Delacroix idealized and romanticized North Africa as "the Orient." But moving beyond the role of the *flâneur* or Charles Baudelaire's observant "painter of modern life," as well as the self-referential and self-critical approaches that dominated art in the 1960s and '70s, today's artists view "modern life" as if interpreting a lab specimen, as a foreign substance to be examined from a calculated remove.

Globalization has intensified a desire for uniqueness and a fear of homogenization, and makes loss or devaluation of the self inevitable. Rene Descartes's question "Who am I?" or Immanuel Kant's "Who are we?" no longer registers with the same force, for both the *I* and the *we* are ambiguous. This ambiguity is overtly tracked in work such as the photographs by artist Nikki S. Lee. In her various "disappearing" acts Lee represents neither herself (I) nor the group (we) into which she attempts to assimilate; rather, she represents "they"— those who infiltrate a particular culture. In such work, the issue of identity politics—gender, race, ethnicity—has given way to identity as the place one is from or operates within. It is possible that *I* and *we* are being subsumed by the ambiguities of place. Still prominent as a point of reference, place grows evermore elusive, sought after yet impossible to delineate. A place like home: There is no such place, only the desire to reconstruct it.

Notes

1. Paul Virilio, *The Vision Machine* (Bloomington: Indiana University Press, 1999), p. 31

2. This quote is taken from an example Michel Foucault gave on the topic of utopian and heterotopian spaces in *The Order of Things: An archeology of the human sciences* (New York: Vintage Books, 1994, 1970), p. 243. He describes the lack of entry or the experience of such while visiting the restored famous bedrooms on the old great farms of Brazil.

The Plural Form of History

Alexander Dumbadze

How will historians remember our moment? Who will be the important artists? What will be the burning issues? Which commentator will have had prescient instincts? A beat on the answers isn't easy to come by, in part because contemporary art is in a state of flux. Few real categorizations apart from "young British artists" have emerged. One would be hard-pressed to name a contemporary critic with the influence of Clement Greenberg, Michael Fried, or Rosalind Krauss in their respective eras. It is difficult today even to identify new intellectual trends. Gone are the days, and they were not so long ago, when artists and commentators passionately argued over identity politics and the subsequent libertarian retort to it, beauty.

Now critical ambivalence is the modus operandi for most of the art world, which is a shame, because progressive art, cosmopolitan in nature, offers an evolving sense of the world. If we look attentively and expand our interpretive horizons, we can begin to write this developing story. Our efforts will be essential for the history of contemporary art, because while we cannot predict the future, and have only an idea of the past, we can observe the present. We can use the tools of the historian (empirical research balanced with imaginative interpretation) to voice the many never-before-discussed situations that define our times. This approach will help ensure, to the degree that it is possible, that future scholars will not ignore the early developments of our global art world. Of course, as you might suspect, it will not be easy. In fact, many think it impossible.

One reason for the doubt is that the scale of the art world is greater than ever. Only thirty years ago, downtown New York was the center of the avant-garde. Now communities all over the world support burgeoning, forward-thinking artistic scenes. But we know this already. We also know there are more galleries, more media coverage, and more artists showing than ever before. Add to this the rise of curators as arbiters of taste, and even then we have not accounted for how many contemporary works of art implicitly and explicitly presume an international point of view. This state of affairs is overwhelming when you think about it, which might explain why many do not.

A historical trepidation began to take hold in the mid 1970s when a new generation of artists, inspired by Conceptual art, embarked upon multivalent explorations of issues including the personal as well as the political. Their art embraced an "anything goes" approach, which liberated many from the perceived limitations of such movements as Minimalism. Nevertheless, critical classifications, such as "pluralism," emerged in an effort to bring order to the aesthetic chaos. Academic commentators such as Rosalind Krauss tried to link the art of the time to past Modernist achievements; others, including Hal Foster, called for a greater historical awareness among contemporary artists.

Yet despite these pleas, a pluralistic ethos continued throughout the '80s. Both artists and writers turned to theoretical ideas to justify their new roles as cultural critics. The subsequent interpretations springing from poststructuralism, semiotics, and postmodernism led to propositions to destabilize traditional social concepts (like the nature of representation) and to fight the hegemony of modernism. The art and the succeeding criticism of it left no room for history's part in depicting the contemporary. Indeed, most thought history was black and white, obscuring the intellectual subtleties introduced by newly embraced philosophical principles. So it makes sense that as the '90s rolled around, theory remained in vogue.

Today we hesitate to speculate on a wide swath of material because we fear we will obviate distinctions. This risk is unavoidable, since our narratives, no matter how conscientious, display our decisions to include and exclude past experiences. Indeed, there is only so much one observer can handle. And not everything can be recorded. Still, to write history is to recreate life with words—the greatest theoretical endeavor in the humanities, for it holds in the balance the memories of real people and real things. History is subjective, and

its outcome varies with each interpretation of events. The more opinions voiced, the more complicated the object of study becomes. Each interacting discourse is an example of the diversity of the past, and as with life itself, history, by its nature, is pluralistic.

So how can we describe the new, cosmopolitan character of contemporary art? How can we meld our plurality with that of history? It will not be enough to resort to accounts employing binary oppositions or simply to follow the well-trodden paths of cause and effect. Instead we need to devise methodologies sympathetic to our times. One approach might be to determine where we share common understanding or speak comparable languages. A consequence of globalization is the increasing homogenization of cultures. We should never neglect differences, but we must acknowledge that at times we recognize and say things in similar, if not identical, ways. We can scrutinize these communicable congruencies by thinking about an artistic endeavor not in terms of "this" or "that," but instead, "this," "that," and "another." In other words, the world is too complicated for an explanation derived from an either/or perspective. Any thoughtful art-historical analysis demands a wider view. This will provide a more flexible way to examine our world, one that takes into account the unpredictability of life and adjusts to the idea that there are innumerable outcomes to any given situation. And because we know language carries the weight of experience, we might actually, with diligence and a little luck, pick out some words that represent our times.

Like it or not, artists have been required during the past ten years to determine where their work stands in relation to the emerging computer-based visual and organizational idioms that have become, in many ways, culturally more significant than the history of art. In the late 1990s, rather than rebel against a mounting enthusiasm for all things high-tech and ultramodern, many artists, including Monique Prieto, Kevin Appel, and Pae White, put image-editing and AutoCAD software to use in the service of painting and installation. The results were probably as appealing as their counterparts in advertising and animation, but in the estimation of many viewers, they were unable to sustain interest on any but a purely optical level, which eventually reduced them to guilty pleasures: Too strident to be introspective and too complicit in design's triumph over homeliness to project any criticality, they could only be evaluated in formal terms. Their flimsiness was aggravated by the general opinion that they were neither historically oriented nor self-aware, and lacked irony. (In other words, they may not have had anything to say, but at least they really meant it.) In an apparently intuitive, practically mute collusion with fashion, the artists involved in this type of practice underscored what we had already learned from the movies: that a disarming vacuity just might be the ultimate form of cool (think of John Travolta as Tony Manero in *Saturday Night Fever* or Marlon Brando in *The Wild One*).

As artists have arrived at a more sophisticated understanding of technology and, in some instances, an awareness that its output can no longer be treated as wholly separate from its processes, the integration of computer-driven design with art seems increasingly superficial. New-media theorist Lev Manovich suggested several years ago that the incipient construct of the database had begun to challenge the hegemony of narrative in our culture, and now it appears that there is a discomfort between these two modes, reflected in many artists choosing, on the one hand, to address the computer as a medium for organizing information or, on the other, to take up a form of narrative or situational practice. Operating under a prescribed logic and maintaining the integrity of specific processes and parameters, works that imitate database functions fall nicely in step with Conceptual art as it continues to develop; they also capitalize on viewers' familiarity with digital media. Whether these works collapse piles of imagery into composites (as do the fantastic meta-places of Benjamin Edwards and the graphs and averages of Jason Salavon), present multiple variations on a given theme (*Sprawlville* by Sven Pahlsson), or mimic the paradoxical capacity of a database to simultaneously stimulate and exhaust (Paul Pfeiffer's *John 3:16*), they reformulate existing information in original (sometimes mutable) structures. However, what makes them so engaging is their inadvertent failure, despite the apparent objectivity of the database, to be anything but subjective; the enter/sort/report methodology may be fundamentally impersonal, but the selection of data to be studied is not; rather, it betrays a variety of curiosities and concerns.

These artists' investigations are counterbalanced by the work of those who avoid any association with digital product in favor of a self-conscious and at times defiantly ham-fisted humanity. As demonstrated by the seemingly endless rows of thumbnails and searchable data tables crowding all manner of

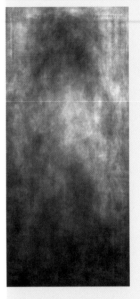

Jason Salavon, *Every Playboy Centerfold, The 1970s (normalized)*, 2002, digital C-print, © 2003 Jason Salavon, courtesy of the artist

websites, even such basic curiosities as sexual fetishes and crime reports are becoming distanced from any narrative framework and succumbing to informational matrices. So it should come as no surprise that there has been a renewed interest in matters such as ambivalence, compromise, and disappointment. Many works (David Rayson's likable depictions of suburbia, Jeff Burton's dramatic, quasi-romantic stills from the sets of porn films) offer unconventional perspectives on mundane themes such as interpersonal relationships and their circumstances. Others invite an examination of cause and effect: The down-in-the-mouth anti-heroes in Ryan Mendoza's power struggles and Brian Calvin's unfussy interiors are quietly beleaguered, as if each had hoped for a different outcome but is coming to terms with what he got. Frequently unremarkable in both focus and execution, these offerings are quiet without appearing sentimental and elicit empathy for their subjects by appearing almost—but not quite—funny.

Just as it appeared that the absorption of techno-design sensibilities into art production would continue unchecked, decoration began to fade, and now more and more artists are scrambling to extract meaning from digital functions by imitating and manipulating them, or mumbling a quiet "no thanks" to the whole thing. The two camps share a low-level anxiety and a growing uncertainty about the value of the visual languages popularized by digital systems and applications. Evidence of an intelligent reassessment of our relationship to these media, the "new tech" and the "no tech" are contributing to an aesthetic climate of welcome multiformity and emphatically unhip ambivalence.

Brian Calvin, *Nowhere Boogie*, 2000, acrylic on canvas, Collection of Kim Light, courtesy of MARC FOXX, Los Angeles

Checklist

Augusto Di Stefano

Working Title, 2002
Oil on canvas
108 x 72 inches
Collection of Jeff and Nancy Moorman

Untitled, 2002
Oil on canvas
16 x 13 inches
Courtesy of the artist

Untitled, 2002
Oil on canvas
16 x 13 inches
Courtesy of the artist

Untitled, 2002
Oil on canvas
16 x 13 inches
Collection of Peter and Julianna Hawn Holt

Untitled (transition), 2002
Oil, acrylic, and molding paste on canvas
16 x 26 inches/each panel 16 x 13 inches
Courtesy of the artist

Untitled, 2002
Oil, acrylic, and molding paste on canvas
16 x 26 inches/each panel 16 x 13 inches
Collection of Peter and Julianna Hawn Holt

Untitled (adaptation), 2002
Oil on canvas
108 x 84 inches
Courtesy of the artist

Adrian Esparza

Touch and Go, 2002
Ceramic
13 x 7 x 8 inches
Courtesy of the artist

Now and Then, 2002
Ceramic
12 x 9 x 6 inches
Courtesy of the artist

Come and See, 2002
Ceramic
18 x 7 x 7 inches
Courtesy of the artist

Here and There, 2002
Serape (Mexican blanket), plywood, and nails
Dimensions variable
Courtesy of the artist

Round and Round, 2002
Acrylic on plywood
18 inches diameter/each
Courtesy of the artist

Solids and Liquids, 2002
Textile paint on full-size sheet
96 x 65 inches
Courtesy of the artist

On and On, 2002
Textile paint on pillowcases
116 x 96 inches
Courtesy of the artist

Joey Fauerso

pleaseandthankyou, 2002
Oil and acrylic on paper
24 x 30 inches
Collection of Linda Pace

pleaseandthankyou, 2002
Oil and acrylic on paper
24 x 30 inches
Collection of Linda Pace

pleaseandthankyou, 2002
Oil and acrylic on paper
24 x 30 inches
Collection of Linda Pace

Bubba, 2002
Oil and acrylic on paper
24 x 30 inches
Progressive Corporation, Cleveland, OH

Bubba, 2002
Oil and acrylic on paper
24 x 30 inches
Courtesy of the artist

Bubba, 2002
Oil and acrylic on paper
24 x 30 inches
Courtesy of the artist

Luce, 2002
Oil and acrylic on paper
24 x 30 inches
Courtesy of the artist

Peter, 2002
Oil and acrylic on paper
24 x 30 inches
Courtesy of the artist

Unknown, 2002
Oil and acrylic on paper
24 x 30 inches
Courtesy of the artist

Neil, 2002
Oil and acrylic on paper
24 x 30 inches
Progressive Corporation, Cleveland, OH

Neil, 2002
Oil and acrylic on paper
24 x 30 inches
Courtesy of the artist

Neil, 2002
Oil and acrylic on paper
24 x 30 inches
Courtesy of the artist

Michael, 2002
Oil and acrylic on paper
24 x 30 inches
Courtesy of the artist

Spin, 2002
Enamel on panel
24 x 24 inches
Courtesy of the artist

*almost in the center and
somewhat to the left*, 2002
Pen on paper
20 x 30 inches
Courtesy of the artist

Flipover, 2002
Oil on panel
12 x 12 inches/each
Courtesy of the artist

enter here, 2002
Oil on panel
12 x 12 inches/each
Courtesy of the artist

Untitled, 2002
Enamel and acrylic on paper
24 x 30 inches
Courtesy of the artist

Robyn O'Neil

Barosaurus, 2001
Pencil on paper
13 $^{1}/_{2}$ x 11 inches
Private collection, Dallas

Brachiosaurus, 2001
Pencil on paper
11 x 13 $^{1}/_{2}$ inches
Collection of John Reoch

Tyrannosaurus, 2001
Pencil on paper
13 $^{1}/_{2}$ x 11 inches
Private collection

Triceratops, 2001
Pencil on paper
24 x 36 inches
Collection of Mark Babcock

Tyrannosaurus, 2002
Pencil on paper
72 x 48 inches
Courtesy of the artist and Angstrom Gallery

Triceratops, 2001
Pencil on paper
11 x 13 $^{1}/_{2}$ inches
Collection of Dina Light, soapfiend.com

Corythosaurus 2, 2001
Pencil on paper
13 $^{1}/_{2}$ x 11 inches
Collection of Dina Light, soapfiend.com

Triceratops and Two Corythosaurus, 2001
Pencil on paper
11 x 13 $^{1}/_{2}$ inches
Collection of Dina Light, soapfiend.com

Eddie's Boat, 2001
Pencil on paper
11 x 13 $^{1}/_{2}$ inches
Collection of David Quadrini

Boats, 2001
Pencil on paper
11 x 13 $^{1}/_{2}$ inches
Collection of Claire Dewar

*A Good Afternoon (Alternative Title:
Coach Martinez is at work)*, 2001
Pencil on paper
10 x 12 inches
Collection of John Reoch

*Accident Victim, Diamond Leruso and
Miami Dave*, 2001
Pencil on paper
11 x 13 $^{1}/_{2}$ inches
Collection of Trenton Doyle Hancock

*Diamond Leruso, Accident Victim and
Runaway Lionel*, 2001
Pencil on paper
10 x 12 inches
Collection of Kerry Inman, Houston; Courtesy of
Bodybuilder and Sportsman Gallery

Miami Dave, 2000
Pencil on paper
10 x 12 inches
Courtesy of the artist and Bodybuilder and
Sportsman Gallery

Runaway Lionel, 2001
Pencil on paper
10 x 12 inches
Courtesy of the artist and Angstrom Gallery

Robert Pruitt

THA Ten Commandments, 2002
Wood, dirt, vinyl, milk crates
17 x 33 x 17 inches
Courtesy of the artist

babee yo roots R showin, 2002
Wood, barbed wire, hair weave
48 x 72 x 9 inches
Courtesy of the artist

*the devil planted fear inside the blak babies,
50 cent sodas in the hood they go crazy*, 2002
Sink and marker
18 (diameter) x 7 inches
Courtesy of the artist

Slave KKKolla, 2002
Basketball hoop
15 x 21 x 24 inches
Courtesy of the artist

Black folks still kaint stick together, 2002
Canned ham, rubber stamp, latex paint
Dimensions variable
Courtesy of the artist

The One and Twos, 2001
Enamel on panel
41 x 31 inches each
Courtesy of the artist

me and this mic is like yin and yang, 2002
Microphone, vacuum cleaner
Dimensions variable
Courtesy of the artist

Juan Miguel Ramos

Mirror Maps, 2001
Four iris prints
47 x 35 inches each
Courtesy of the artist

Sofia's Map, 2001
Seven digital prints
22 x 30 inches each
Courtesy of the artist

Ghost Story, #1-10, 2001
Ten digital prints
18 x 24 inches each
Courtesy of the artist

Secret City, #1-8, 1999
Eight photocopies on archival paper
18 x 24 inches each
Courtesy of the artist

Secret City, #9-12, 2001
Four photocopies on archival paper
18 x 24 inches each
Courtesy of the artist

Secret City, #13-17, 2002
Five photocopies on archival paper
18 x 24 inches each
Courtesy of the artist

North South East West, 2001
Four iris prints
33 x 22 inches each
Courtesy of the artist

Irene Roderick

Façade Series: Double Arches, 2001
Latex primer on architectural film
96 x 120 inches
Courtesy of the artist

Façade Series: Bodice, 2001
Latex primer on architectural film
60 x 96 inches
Courtesy of the artist

Façade Series: Tomb, 2002
Latex primer on architectural film
60 x 96 inches
Courtesy of the artist

Façade Series: Pink, 2002
Latex primer on architectural film
96 x 120 inches
Courtesy of the artist

Façade Series: Motorcycle I, 2002
Latex primer on architectural film
60 x 96 inches
Courtesy of the artist

Chris Sauter

Engaging the Minotaur, 2003
Mixed media installation
Dimensions variable
Courtesy of the artist

 Living Room
 Wood paneling, carpet, chair, recliner, TV,
 and stand

 Mom/Dad, Bull/Cowboy
 Framed photograph

 Hat
 Wooden hat rack, straw cowboy hat (Resistol),
 tooled leather hat band, bucket

 Minotaur Testicles
 Tooled leather, tacks

 Minotaur Ovaries
 Tooled leather, tacks

 Two Step
 Video

 Dining Room Bleachers
 White oak, upholstery

 Dining Room Arena
 White oak

 Engage the Minotaur
 Video

 Bull Family Tree
 Branded bull hide, nails

 Cowboy Family Tree
 Vest, embroidery

 Gender Brands
 Forged steel

Brent Steen

It's okay...okay, 2001
Video projection
Courtesy of the artist and Inman Gallery, Houston

(Sad In)...it doesn't make sense, 2002
Pencil on canvas
54 x 72 inches
Courtesy of the artist and Inman Gallery, Houston

Hugging the window, 2002
Pencil on canvas
54 x 72 inches
Courtesy of the artist and Inman Gallery, Houston

What about a regular cry?
(My conversation with Kurt Cobain), 2002
Pencil on paper
30 x 44 inches
Private collection

Marshall Thompson

Untitled (lighthouse), 2001
Birch, acrylic, electronics and laminated paper
12 ¹/₂ x 1 x 1 ³/₄ inches
Courtesy of the artist and Angstrom Gallery

Ghost Ship, 2001
Birch, acrylic, electronics and laminated paper
10 x 12 ¹/₂ x 1 ³/₄ inches
Courtesy of the artist and Angstrom Gallery

Pantswave, 2000
Denim
30 x 108 inches
Courtesy of the artist and Angstrom Gallery

Untitled (Porthole #1), 2002
MDF and Plexiglas
12 x 13 ¹/₂ x ³/₄ inches
Courtesy of the artist and Angstrom Gallery

Untitled (Porthole #2), 2002
MDF and Plexiglas
17 x 13 ¹/₂ x ³/₄ inches
Courtesy of the artist and Angstrom Gallery

Untitled (Diamond #1), 2002
Wood, Plexiglas, and electronics
16 ¹/₂ x 9 ¹/₂ inches
Courtesy of the artist and Angstrom Gallery

Untitled (Diamond #2), 2002
Wood, Plexiglas, and electronics
6 ¹/₂ x 9 ¹/₂ inches
Courtesy of the artist and Angstrom Gallery

Untitled, 2002
Wood and Plexiglas
12 x 15 ³/₄ x 1 ³/₄ inches
Courtesy of the artist and Angstrom Gallery

Untitled, 2002
Wood and Plexiglas
15 ¹/₄ x 12 x 1 ³/₄ inches
Courtesy of the artist and Angstrom Gallery

Brad Tucker

Singles, 2002
Wood, fabric, turntable parts, speaker, 12
seven-inch acetate records, 2 customized
turntables (one with built-in speaker),
one speaker, shelf with 12 record covers featuring
images of the 24 recording artists (one per side)
Courtesy of the artist and Inman Gallery, Houston

Double Drum Speaker (figure eight), 2001
Latex on wood, fabric, speakers, drum leg
31 x 27 ¹/₂ x 3 inches
Collection of Gregory Higgins

Two Lefts, 2002
Cast foam and plastic
Variable dimensions
Collection of Dianne and Mark LaRoe

Who's Asking, 2001
Acrylic on canvas
24 x 18 inches
Collection of Richard Robertson

Fine, 2001
Painted wood
19 ¹/₂ x 44 x ³/₄ inches
Collection of Robert J. Card, M.D.,
and Karol Kreymer

Lee, 2000
Foam rubber
24 x 24 x 4 inches
Courtesy of the artist and Inman Gallery, Houston

Slythering, 2000
Latex and wood
15 ¹/₂ x 8 ¹/₂ x ³/₄ inches
Anonymous Dallas collector

Athena, Aphrodite, Hera, 2000
Acrylic, various other fabrics, wood
26 x 58 x 4 inches
Courtesy of the artist and Inman Gallery, Houston

Bond, 2001
Plastic and wood
10 ¹/₄ x 12 ³/₄ x ³/₄ inches
Collection of John Griffith and Angie Paez

Head Phones, 2002
Cast plastic, foam, and fabric
Dimensions variable
Courtesy of the artist and Lombard-Freid Fine Arts

June Bug (whistle), 2002
Wood, paint, and polyester
12 x 19 x 9 inches
Courtesy of the artist and Lombard-Freid Fine Arts

Published by the Dallas Museum of Art.
Distributed by Texas A&M University Press.

This catalogue accompanies an exhibition of the
same name appearing at the Dallas Museum of Art
from February 23 to May 11, 2003.

The exhibition *Come Forward: Emerging Art in Texas*
is organized by the Dallas Museum of Art.
Curator: Suzanne Weaver
Curatorial Administrative Assistant: Wood Roberdeau
Director of Exhibitions and Publications: Tamara
Wootton-Bonner
Exhibitions and Publications Assistant: Eric Zeidler

All works are © 2003 the artist
All photography, unless otherwise noted, is by
Brad Flowers, © 2003 Dallas Museum of Art.
Images pp. 22-23, 30-31, 62-63, 70-71, 94-95,
102-103 courtesy of the artists
All images of work by Juan Miguel Ramos are
courtesy of the artist

Design by Sibylle Hagmann, Kontour, Houston
Edited by Alice Gordon, New York City
Printed by Grover Printing, Houston

Library of Congress Control Number: 2002111856

ISBN: 0-936227-26-5

Exhibition support has been provided by

Nancy and Tim Hanley

The Contemporary Art Fund through the gifts of
Anonymous
Naomi Aberly and Laurence Lebowitz
Arlene and John Dayton
Mr. and Mrs. Vernon Faulconer
Nancy and Tim Hanley
The Hoffman Family Foundation
Cindy and Howard Rachofsky
Evelyn P. and Edward W. Rose
Gay and Bill Solomon
Gayle and Paul Stoffel

Additional support has been provided by
National Endowment for the Arts
Jones Day
U.S. Trust Company of Texas

Exclusive air transportation has been provided by
Southwest Airlines

Front cover (left to right): Augusto Di Stefano, *Untitled*
(detail), 2002; Robyn O'Neil, *Tyrannosaurus* (detail), 2002;
Adrian Esparza, *Come and See* (detail), 2002; Juan Miguel
Ramos, *Mirror Maps* (detail), 2001; Brad Tucker, *Head
Phones* (detail), 2002, photograph courtesy of Lombard-
Freid Fine Arts

Inside front cover (left to right): Robert Pruitt, Joey
Fauerso, Marshall Thompson, Robyn O'Neil, Chris Sauter,
and Augusto Di Stefano

Back cover (left to right): Robert Pruitt, *babee yo roots R
showin* (detail), 2002; Marshall Thompson, *Untitled (light-
house)* (detail), 2001; Brent Steen, Still from *It's
okay...okay* (detail), 2001, image courtesy of the artist; Joey
Fauerso, *Bubba* (detail), 2002; Irene Roderick, *Façade
Series: Double Arches* (detail), 2001; Chris Sauter,
Minotaur Testicles (detail), 2003

Inside back cover (left to right): Juan Miguel Ramos,
Adrian Esparza, Brent Steen, Irene Roderick, Brad Tucker

ISBN 0-936227-26-5
90000
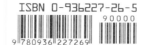
9 780936 227269